WORLD FILM LOCATIONS NEW ORLEANS

Edited by Scott Jordan Harris

First Published in the UK in 2012 by Intellect Books, The Mill, Parnall Road, Fishponds, Bristol, BS16 3JG, UK

First Published in the USA in 2012 by Intellect Books, The University of Chicago Press, 1427 E. 60th Street, Chicago, IL 60637, USA

Copyright © 2012 Intellect Ltd

Cover photo: *Pretty Baby* (Paramount / The Kobal Collection)

Copy Editor: Emma Rhys

A Catalogue record for this book is available from the British Library

World Film Locations Series
ISSN: 2045-9009
eISSN: 2045-9017

World Film Locations New Orleans
ISBN: 978-1-84150-587-9
eISBN: 978-1-84150-589-3

Printed and bound by Bell & Bain Limited, Glasgow

WORLD FILM LOCATIONS
NEW ORLEANS

EDITOR
Scott Jordan Harris

SERIES EDITOR & DESIGN
Gabriel Solomons

CONTRIBUTORS
Samira Ahmed
Nicola Balkind
John Berra
Marcelline Block
Jez Conolly
Scott Jordan Harris
Peter Hoskin
Simon Kinnear
Neil Mitchell
Elisabeth Rappe
Jonathan Ray
Pamela C. Scorzin

LOCATION PHOTOGRAPHY
Gabriel Solomons and Paul Dowling
(unless otherwise credited)

LOCATION MAPS
Joel Keightley

PUBLISHED BY
Intellect
The Mill, Parnall Road,
Fishponds, Bristol, BS16 3JG, UK
T: +44 (0) 117 9589910
F: +44 (0) 117 9589911
E: info@intellectbooks.com

Bookends: Canal Street (Gabriel Solomons)
This page: 12 Rounds (Kobal)
Overleaf: The Curious Case of Benjamin Button (Kobal)

CONTENTS

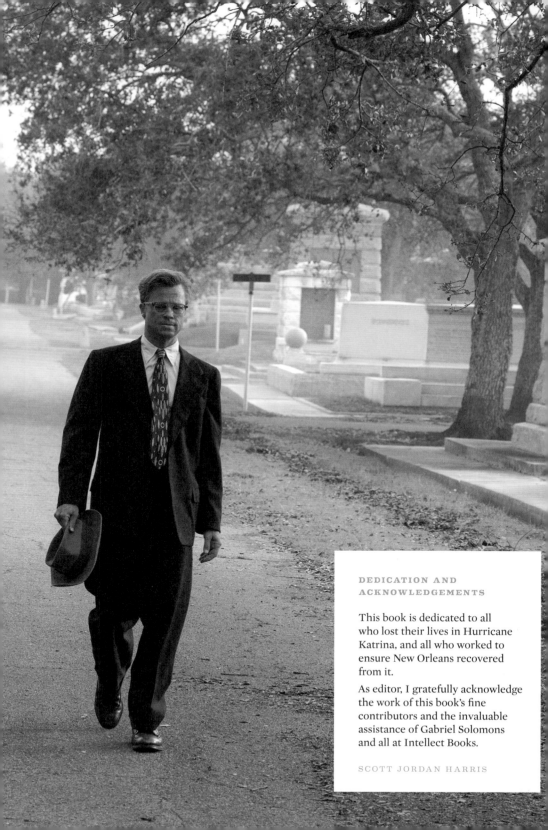

DEDICATION AND
ACKNOWLEDGEMENTS

This book is dedicated to all
who lost their lives in Hurricane
Katrina, and all who worked to
ensure New Orleans recovered
from it.

As editor, I gratefully acknowledge
the work of this book's fine
contributors and the invaluable
assistance of Gabriel Solomons
and all at Intellect Books.

SCOTT JORDAN HARRIS

INTRODUCTION

World Film Locations New Orleans

NEW ORLEANS HAS A UNIQUE ATMOSPHERE. Cajun culture and the spirit of the Mardi Gras; jazz music and an unmistakable dialect; Creole architecture and Creole cuisine; associations in the popular imagination with voodoo and vampires; proximity to the rolling Mississippi and fetid swamp land... all of these combine to create a city that is like no other in America – and, indeed, like no other on Earth.

In recent years, those who lived in the aftermath of Hurricane Katrina, a mournful spirit has been added to that atmosphere: an ever-present sense of loss and of the fragility not just of a life, or a house, but of an entire city. This is tempered, though, by an even stronger spirit: one of resilience and resurrection. No other art form, not even jazz, has done as much to spread this spirit of New Orleans as film – and this book is an attempt to capture some of that spirit by analysing, and celebrating, the ways it has been communicated by film-makers.

Featured here are seven essays – six on specific aspects of New Orleans film-making and one on New Orleans film-making in general – that explain and investigate what New Orleans means to cinema and what cinema means to New Orleans. Featured besides them are 46 'scene reviews', in which an individual film scene shot in New Orleans is discussed and illustrated both with images from the film and pictures of its specific location.

These locations include bridges and churches; graveyards and hotels; streets and squares; a prison and a zoo. The films in which they feature were made across nine decades and include dramas and documentaries; road movies and romances; musicals and animation; westerns and thrillers. Some show the city as it appears to its inhabitants; others show it as it appears to outsiders. By guiding the reader through these film scenes, and around the locations they use, it is our aim that *World Film Locations: New Orleans* will become a guide book for the imagination.

The book is not, though, a standard travel guide and it is not intended to be one. Nor is it a catalogue of all the films ever made in New Orleans or of all the locations used in them. It is instead a brief trip through the city as seen through the eyes of the film-makers who flock to it.

Readers can use the book to lead them on a trip around the city – by foot, by car or, of course, by streetcar – to visit dozens of locations, some no longer in existence, that have been immortalised in the likes of *Easy Rider* (Dennis Hopper, 1969) and *The Cincinnati Kid* (Norman Jewison, 1965), *The Big Easy* (Harry Shearer, 2010) and *A Streetcar Named Desire* (Elia Kazan, 1951). Others less inclined to travel can use the book to tour New Orleans, and the films in which it stars, without ever leaving home.

Not every film in this book is a classic and not every location normally attracts tourists – but they all express something of the essence of The Big Easy on the big screen. ✠

Scott Jordan Harris, Editor

NEW ORLEANS
City of the Imagination

Text by
JONATHAN RAY
– with –
SCOTT JORDAN
HARRIS

> 'Don't you just love those long rainy afternoons in New Orleans when an hour isn't just an hour, but a little piece of eternity dropped into your hands, and who knows what to do with it?'
> – TENNESSEE WILLIAMS, *A STREETCAR NAMED DESIRE*

THERE IS NO CITY LIKE NEW ORLEANS. For a long time, that was why Hollywood came here. New Orleans always conjured up images of mule-drawn carriage-rides through the French Quarter; of listening to jazz at Preservation Hall; of eating beignets at Café Du Monde; and maybe even of taking the time to sit on a balcony and enjoy a Sazerac. That has all changed. In the twenty-first century, New Orleans has become a true player in the TV and film industries. Our city is now known not only as the birthplace of jazz and The Big Easy, but also as Hollywood South.

New Orleans has always had a vivid history on the silver screen. That history can be traced from the American Mutoscope Company's short 1898 documentaries, whose subjects are revealed by their titles: *Mardi Gras*, *City Hall*

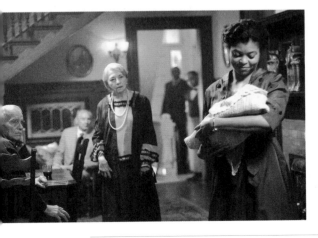

and *Loading A Mississippi Steamboat*. It runs through Cecil B. DeMille coming here in 1938 to film *The Buccaneer*, the first talking picture to showcase this special city. It includes Vivien Leigh stepping off the train in Elia Kazan's *A Streetcar Named Desire* (1951) and uttering the famous words, 'Well... they told me to take a streetcar named desire and transfer to one called cemeteries, and ride six blocks and get off at Elysian Fields'.

It encompasses the sleaze and corruption exposed in crime thrillers such as *The Big Easy* (Jim McBride, 1986) and *Angel Heart* (Alan Parker, 1987). And it runs up to Brad Pitt playing a man aging backwards in David Fincher's love letter to New Orleans, *The Curious Case of Benjamin Button* (2008). Those films were all meant to celebrate this amazing city: its culture, its people and its architecture.

Since huge tax incentives for film production were put in place in 2002, film-makers have been flocking here – and not just to make movies about New Orleans. We have everything a film-maker needs to start and finish their project. We have a Panavision camera shop, pre- and post-production facilities, movie studios and special effect houses. A film can be made here entirely, without shipping anything off to Los Angeles or New York, the only two cities in America that currently film more movies than we do.

Two thirds of the films being produced here are no longer set here. Gone are the days of showing off the French Quarter and its amazing balconies. Gone are the days of

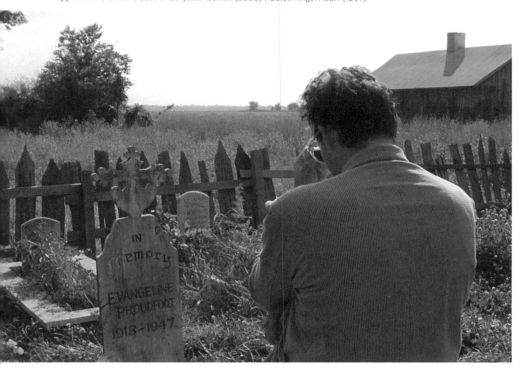

watching people suck the head and squeeze the tails of crawfish. Now, we see *G.I. Joe: Retaliation* (Jon M. Chu, 2012) turn downtown New Orleans into Pakistan; we watch Ryan Reynolds fighting comic book monsters in *The Green Lantern* (Martin Campbell, 2011); and we host Jason Statham battling bad guys in 'downtown Chicago' in *The Mechanic* (Simon West, 2011). Our facilities allow film-makers to do whatever is necessary to turn New Orleans into any city or country they want.

This is not a bad thing. In fact, it is a wonderful thing. The Hollywood spotlight is shining on us and showing a new side of New Orleans to the world. This does not lessen the old magic of the city: it simply enhances it. Through all our recent struggles and setbacks, the people of New Orleans have persevered and even moved forward. Now, as John Goodman's Creighton Bernette said in season 1 of HBO's *Treme*, 'New Orleans is... a great city – a city that lives in the imagination of the world.' ✤

> **The Hollywood spotlight is shining on us and showing a new side of New Orleans to the world. This does not lessen the old magic of the city: it simply enhances it.**

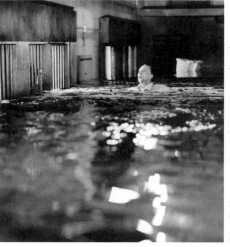

Below *Bad Leutenant: Port of Call New Orleans* (2009)

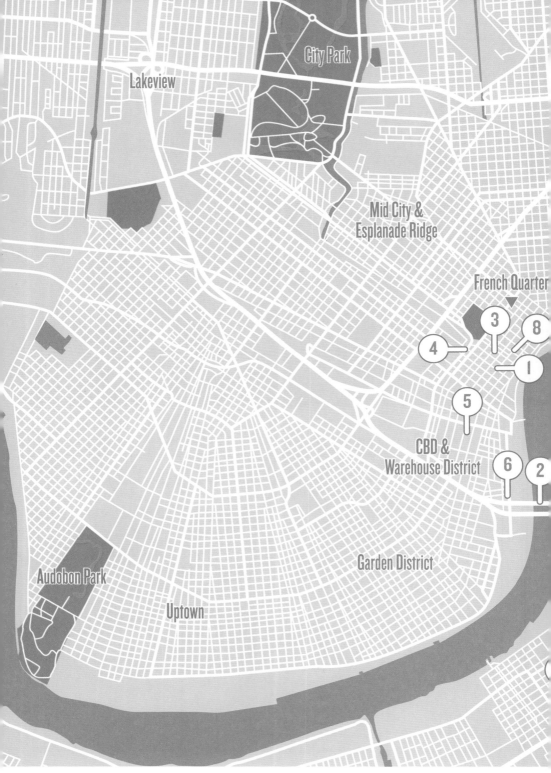

Lakeview

City Park

Mid City &
Esplanade Ridge

French Quarter

3
8
4
1
5

CBD &
Warehouse District

6
2

Garden District

Audobon Park

Uptown

NEW ORLEANS LOCATIONS

SCENES 1-8

JEZEBEL (1938)

EVEN IF HE HAD WANTED TO, William Wyler couldn't shoot on location in the St Louis Hotel for his *Jezebel*. After all, the St Louis Hotel – once a shimmering landmark of 19th Century New Orleans – had decayed and crumbled decades before Wyler started filming; it was the victim of a hurricane in 1915. But no matter. The reconstruction that was built on a studio back lot captured the hotel's old opulence in spades. Its staircases sweep, its chandeliers glisten, and its bar goes on and on and on. Besides, there is something about the real-life decline of the St Louis that is thematically suited to Wyler's film. In early scenes, the hotel is shown as a decorous place for a decorous society. Men wander around upright and top-hatted, and resolve their disputes with very proper duels. But later, as yellow fever descends upon the city, it is a site of disorder and devastation. The top hats are now clustered and confused, almost a visual representation of contagion. The men beneath them are sweaty and afraid. And into this steps Preston Dillard, played by Henry Fonda. Is it any wonder that he collapses before the scene is through? Is it any wonder that nobody, but one friend, rushes to help him? Propriety died with the fever. **➜Peter Hoskin**

(Photo © Paul Dowling)

Directed by William Wyler
Scene description: *Fear, disorder and yellow fever at the St Louis Hotel*
Time code for scene: 1:24:14 – 1:27:19

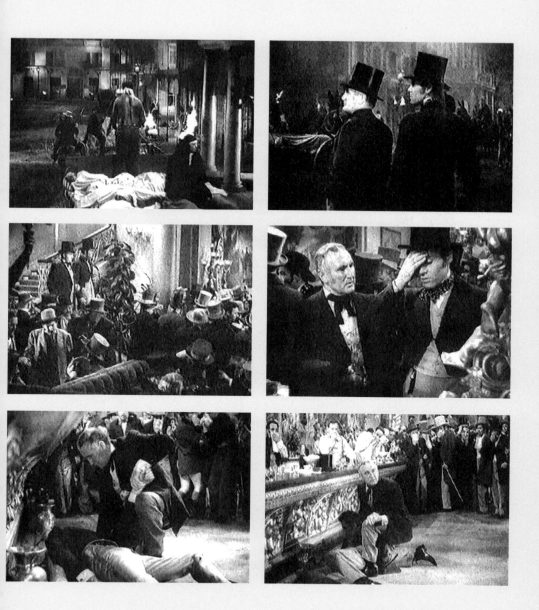

MODERN NEW ORLEANS (1940)

LOCATION *The Huey P. Long Bridge, over the Mississippi River, Jefferson Parish,*

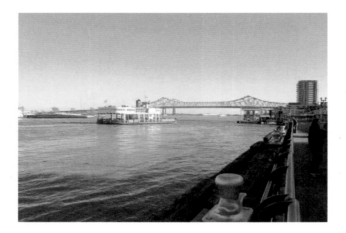

THIS EIGHT-MINUTE documentary short, designed – as its title suggests – to showcase New Orleans's vibrant modernity, is one of the famous 'Traveltalks' made by James 'The Voice of the Globe' Fitzpatrick and distributed by MGM. It opens with an astonishing Technicolor shot of a bridge curving towards the camera, a steam train forcing out a stream of smoke as it approaches. 'En route to New Orleans,' intones Fitzpatrick. 'We cross the Mississippi River, by way of this magnificent 13 million dollar structure, named the Huey Long Bridge in honour of the late Huey P. Long, former governor of Louisiana, to whom New Orleans is largely indebted for this wonder of modern engineering, which characterises the indomitable spirit of the people of Louisiana and indicates the great strides that are being made in that state for economic recovery.' The music, urgent and hopeful, works in the chug of a train, as the locomotive snakes out of shot, an obvious image of America emerging from the ravages of the Great Depression. The bridge was only five years old at the time and remained unchanged for another 46 years, until 2006, when a massive widening project designed to turn its two nine-foot lanes into three eleven-foot lanes began. When that project is complete (which, at time of writing, should be in 2013), the bridge will perhaps become again what it was in 1940: a marvel of engineering fit to be used by film-makers as one of America's cinematic advertisements for itself. **➤Scott Jordan Harris**

(Photo © Gabriel Solomons)

Directed by James A. Fitzpatrick
Scene description: A bridge to the future
Timecode for scene: 0:00:31 – 0:01:07

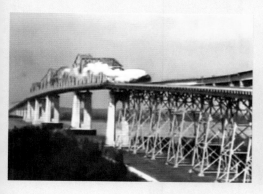 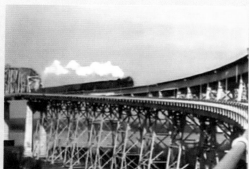

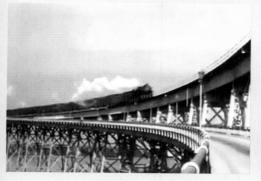 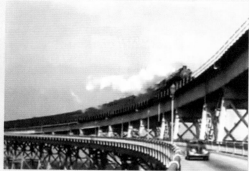

SARATOGA TRUNK (1945)

LOCATION *(A Hollywood re-creation of) The French Opera House, now The Inn on Bourbon, 541 Bourbon Street, LA 70130*

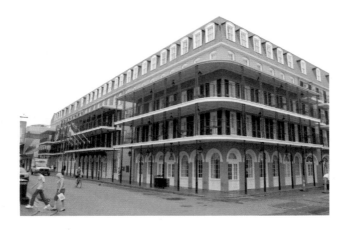

A LINGERING CLOSE-UP of an opera programme announces the setting: 'The Opera House, New Orleans'. In this scene, the location takes top billing – and with good reason. The French Opera house is, historically, architecturally and culturally, one of the most significant buildings in New Orleans's history. And yet it no longer exists. Constructed in 1859, it soon became New Orleans's key cultural arena; the opening of its opera season was the opening of the city's social season. In the early twentieth century, however, the Opera House struggled financially and was donated to Tulane University. At its grand reopening in 1919, it burned to the ground. It was never rebuilt. Which is why it needed to be recreated for *Saratoga Trunk*, in which Ingrid Bergman's Clio, an illegitimate daughter of the snobbish Dulaine family, returns to New Orleans to revenge herself on the relatives who made her mother an outcast. In this scene, she strikes at the heart of New Orleans's Creole aristocracy – by causing a scandal at the first night of the opera. She stands and scans the audience with her opera glasses, inviting people to stare at her. Soon, audience members begin to whisper. Overcome by embarrassment, the Dulaines leave their box. It's a short scene but one of the film's best. Besides quickly advancing the plot, it underlines the importance of the French Opera house in nineteenth century New Orleans. As Cleo proves, if you could make a scene there, you could make a scene anywhere. ⁕**Scott Jordan Harris**

(Photo © Paul Dowling)

Directed by Sam Wood
Scene description: A Night at the Opera
Timecode for scene: 0:48:07 – 0:49:49

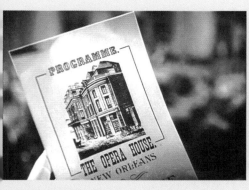
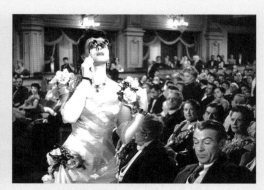
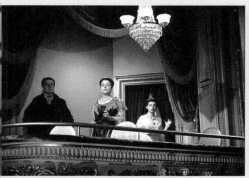

NEW ORLEANS (1947)

LOCATION *(A fictionalised recreation of) Basin Street, Storyville*

FITTINGLY, STORYVILLE is one of the most storied areas in New Orleans history. While it stood, it was the city's red light district, set up in the 1890s (to ensure that the more unseemly side of New Orleans nightlife was confined to one area) and outlawed in 1917 (when regulations preventing prostitution within five miles of military bases came into effect). Legends say that jazz was born in Storyville's brothels and bars (it actually developed all around the city), and this idea is propagated in the 1947 film that bears New Orleans's name. The movie is far from a classic, but it contains some classic musical scenes, one of which comes when the king and queen of jazz, Louis Armstrong and Billie Holliday, perform the title song in a Basin Street bar. Miralee Smith (Dorothy Patrick) is white, high-born and about to make her opera debut – but it isn't classical singing that has seized her soul. She is in love with jazz and so persuades her maid, Endie (Holliday), to take her to Basin Street while her mother, the disapproving Mrs Smith, is out for the evening. As soon as the ladies walk into their chosen dive, Endie joins the band. Holliday hated her role, and had signed on for the film thinking she would be playing herself. In this scene, she is. New Orleans jazz doesn't get much more memorable than Billie Holliday turning to Louis Armstrong and asking, 'Do you know what it means to miss New Orleans?'
•◦Scott Jordan Harris

(Photo © Paul Dowling)

Directed by Arthur Lubin
Scene description: 'Do you know what it means to miss New Orleans?'
Timecode for scene: 0:18:28 – 0:21:27

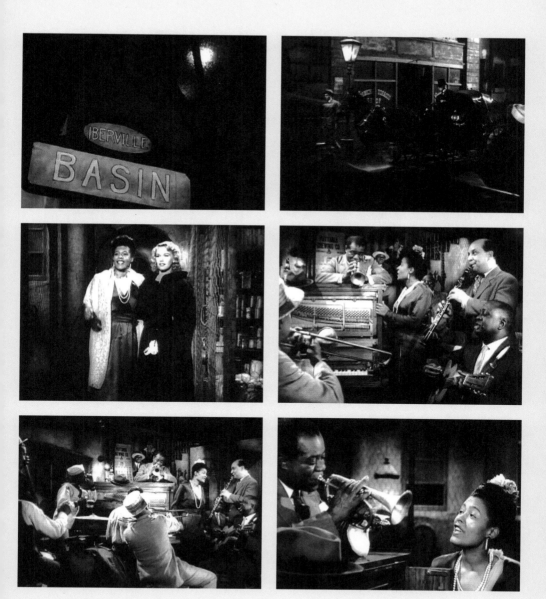

PANIC IN THE STREETS (1950)

Lafayette Square, 500 Saint Charles Avenue, LA 70130

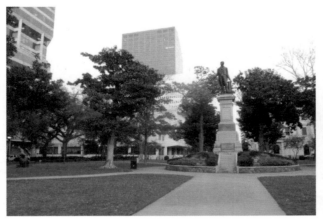

ALL NEW ORLEANS: that's what you get from Elia Kazan's noirish thriller *Panic in the Streets*. Right from the very opening credits, which feature a tracking shot down the bar fronts of Bourbon Street, it's clear that this film is embedded in the city like a splinter – it just won't leave its streets and back alleys unless it's squeezed out. Except, unlike normal splinters, this one is a treat. In his hunt for a murderer who could kill a thousand times over, thanks to carrying the plague, Richard Widmark's health officer hurries everywhere from the beat-down docks of the Mississippi to the grander parades of Lafayette Square. And it's the latter where he meets with the Mayor, at night, to explain why a journalist has been locked up to prevent mass hysteria. 'The minute he prints [the story],' snarls our hero from the shadows, 'the men we're looking for will leave the city. Anyone leaving here with plague endangers the entire country.' Given Kazan's burgeoning anti-communist beliefs, the political parallels should be clear. But if they're not, just compare Widmark's monologue with the words of J. Edgar Hoover, the first director of the FBI. 'Communism,' said Hoover, 'is not a political party. It is a way of life — an evil and malignant way of life. It reveals a condition akin to disease that spreads like an epidemic and, like an epidemic, a quarantine is necessary to keep it from infecting the Nation.' The Cold War was now being fought on screen. •➤*Peter Hoskin*

(Photos © Gabriel Solomons)

Directed by Elia Kazan
Scene description: *A 'plague' called Communism*
Timecode for scene: *1:09:50 – 1:13:40*

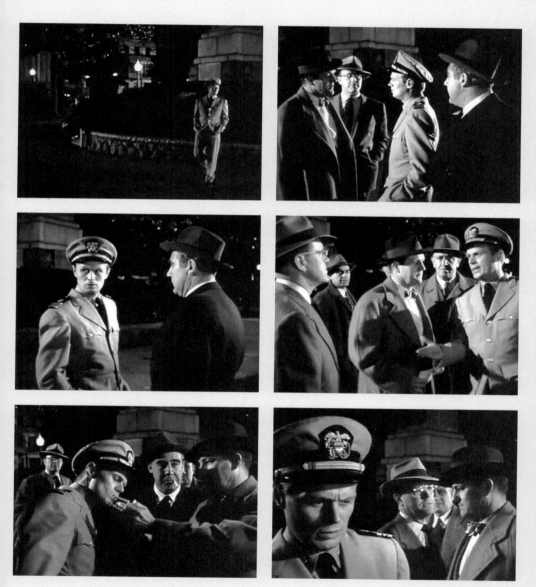

A STREETCAR NAMED DESIRE (1951)

The Louisville and Nashville Train Station, at the foot of Canal Street

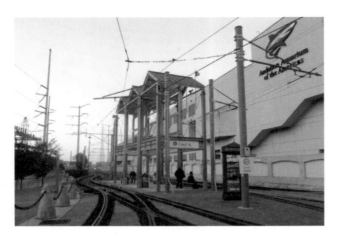

WITH ITS FETID ATMOSPHERE of sublimated menace and incipient insanity, dripping sweat and sexual tension, A Streetcar Named Desire captures the quintessence of New Orleans – or at least the quintessence of New Orleans as film-makers often like to show it. It is remarkable, then, that only one scene in the film was shot in the city: the opening sequence, showing the arrival of a train at the Louisville and Nashville station and the arrival of Vivien Leigh's Blanche Dubois in New Orleans. A train ploughs through the rough-looking landscape around the station and the film cuts to Canal Street, bright and bustling with polished cars. We move past the hustle of the general waiting room to the platform where, through a wall of white smoke, the timid Blanche appears. 'They told me to take a streetcar named "Desire",' she says to a smart young sailor, and he helps her to it; the first time we see her she is relying on the kindness of a stranger. Even in this, some of the only location shooting in a movie that could otherwise almost be a filmed a stage production, Kazan opts for claustrophobia. The crowds jostle and surge, and Blanche looks fragile and lost among them. The congested station was a fitting choice of setting: as a report (by Bartholomew & Associates) noted in 1927, it is 'practically inaccessible [...] Taxis line up in the driveway [...] and [...] in Canal Street where they obstruct traffic'. Thankfully, they did not obstruct that streetcar named 'Desire'.
➡ ***Scott Jordan Harris***

(Photo © Gabriel Solomons)

Directed by Elia Kazan
Scene description: 'They Told Me to Take a Streetcar Named Desire'
Timecode for scene: 0:01:07 – 0:02:05

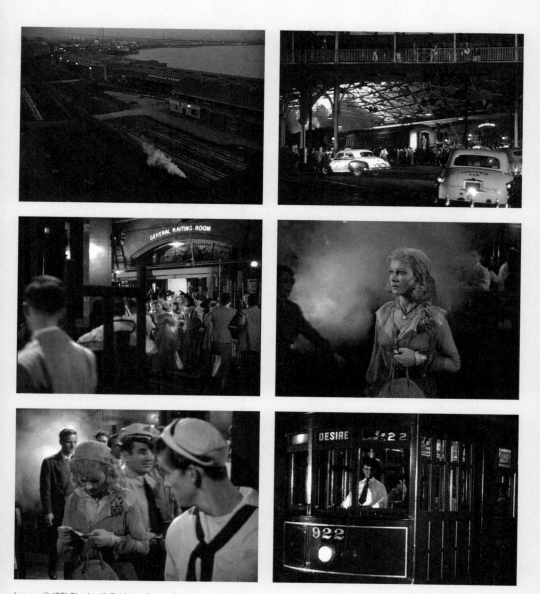

THE BUCCANEER (1958)

*(A Hollywood recreation of) Chalmette Battlefield,
8606 West Street Bernard Hwy, Chalmette, LA 70043*

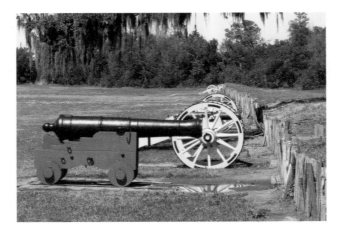

A REMAKE OF Cecil B. DeMille's 1938 film of the same name, *The Buccaneer* features Yul Brynner stepping into the buccaneer boots of Jean Lafitte. Charlton Heston refreshes the role of Andrew Jackson, leading his hastily assembled army into a proud victory against the British Imperialists in one of the most famous events in Louisiana history: the Battle of New Orleans. The Chalmette Battlefied is here recreated in a Paramount studio, which accounts for the film's version of the battle being such an understated affair. Shrouded in fog, Jackson's army hold fast as their Tartan-clad enemy approaches. As the Imperialists move closer, we hear shrill bagpipes and the thumping of drums. Creeping into an ambush position to alert the army of its rival's whereabouts, Lafitte and his men hide among gnarled tree roots and shoot a blazing warning shot across the fog-filled sky. Far from the colourful culture of New Orleans or the homey bayou, a scarlet army trudges in unison across the rugged, grassy plane. As the British march defiantly into flying bullets, Jackson's forces hold fast behind a fort of sandbags; no man's land has no place in this stand-off, but the distance between the two sides is unrevealed as they fire at each other. The Scots have come a long way since the Battle of Bannockburn in 1314 but, 501 years later on the Chalmette Battlefield, we see so many of them cut down by US forces – never sent homeward, nor to think again.
➻**Nicola Balkind**

(Photo © Peter Connolly)

Directed by Anthony Quinn
Scene description: The Battle of New Orleans
Time code for scene: 1:24:25 – 1:42:28

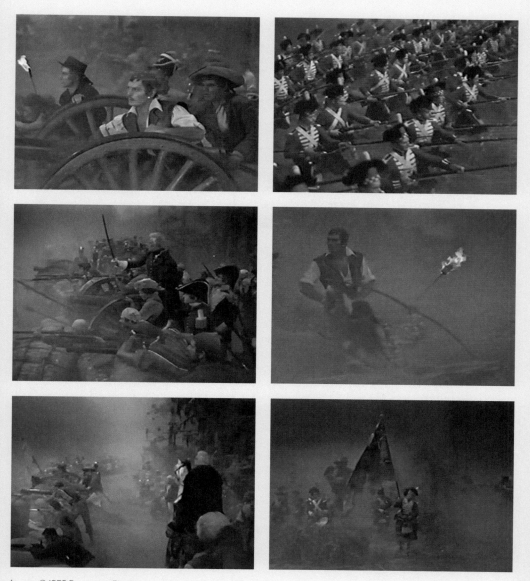

KING CREOLE (1958)

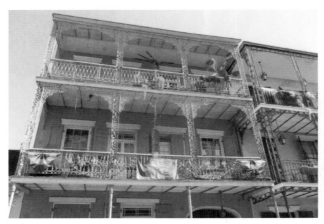

CRITICS ARE SELDOM KIND to Elvis Presley films but *King Creole* is something of an exception: it's universally held to be one of The King's best films and often said to contain his best performance. (It was also, apparently, Elvis' favourite among his movies.) As its title suggests, *King Creole* is set in The Big Easy; its most memorable scene was shot on the historic Royal Street and showcases one of its characteristic iron lace balconies. A black crawfish seller, played by jazz singer Kitty White, drives her horse cart along the street. She calls out, 'Crawfish! Fresh and ready!' in such a melodic tone that we are unsurprised to hear music begin as a song starts. Up in his apartment, Elvis, as high-school student Danny Fisher, sings a reply. He pauses to comb his perfect hair, walks out onto his balcony, and the pair proceeds to duet – Kitty on the street below and Elvis on the balcony above. As he leans against the aforementioned iron lace (some of which has decorated Royal Street since the eighteenth century), Presley looks as beautiful and beguiling as any man has ever been onscreen. Royal Street now positions itself as a more refined version of its French Quarter cousin, Bourbon Street, and hosts fine restaurants and even finer antique shops, as well as numerous art galleries. It also often hosts street musicians – and, while it's worth making a trip to see them, none of them can quite compete with the King. ➛***Scott Jordan Harris***

(Photos © Gabriel Solomons)

Directed by Michael Curtiz
Scene description: 'Crawfish!'
Timecode for scene: 0:02:29 – 0:04:43

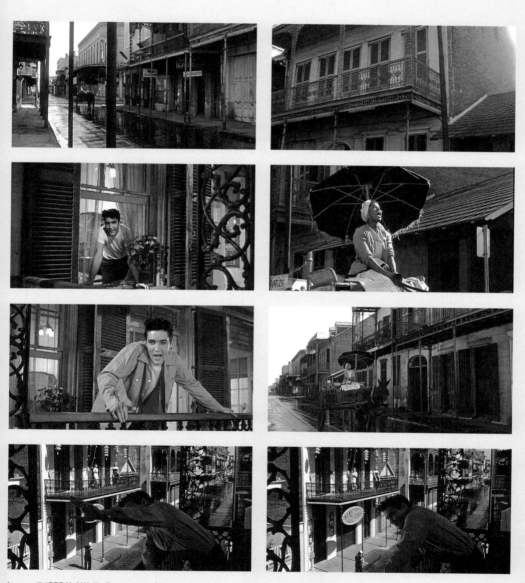

ALL THAT JAZZ

Text by MARCELLINE BLOCK

New Orleans Jazz Onscreen

JAZZ MUSIC PERMEATES films depicting New Orleans. The city's would-be anthem, 'When the Saints Go Marching In' – which, although originally a spiritual, was immortalized by Louis Armstrong through his trumpet and signature raspy voice – is featured on the soundtracks of innumerable New Orleans films.

The music of many legendary jazz musicians from the Big Easy infuses films either made or set in the city, include pioneering performers such as Tony Jackson (1876–1921), whose 1912 song 'Pretty Baby' inspired Louis Malle's eponymous 1978 film about Storyville; Jelly Roll Morton (1885–1941), the first to publish a jazz melody ('Jelly Roll Blues'); and Armstrong (1901–71), who appears as versions of himself in several films, including Arthur Lubin's *New Orleans* (1947) and Howard Hawks' *A Song is Born* (1948).

Among the contemporary New Orleans jazz musicians who are heard, and often seen, in film is the renowned Marsalis musical dynasty, which comprises patriarch Ellis, Jr., a pianist, and his four sons: saxophonist Branford; trumpeter Wynton; trombonist and record producer Delfeayo; and drummer Jason. John Amiel's 1990 film *Tune in Tomorrow*, which explores post-World War II New Orleans's radio soap

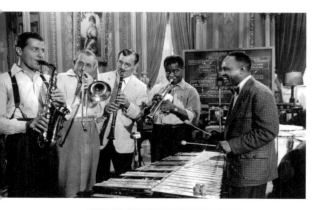

opera scene (and was filmed mostly on location), highlights Wynton Marsalis' original score, which he performs with his band, and features him in a cameo appearance.

'The same vibrancy that helped create jazz a century ago is still present in New Orleans today, where music remains a vital part of their cultural life,' states conductor and saxophonist Loren Schoenberg in *Jazz: The Story of America's Music* (Ken Burns, 2000). Much of that vibrant cultural life is expressed in film by jazz, even when that jazz is not authentically from New Orleans.

For example, Texas-born Jack Teagarden and his Chicago-based jazz band can be seen and heard in Victor Schertzinger's 1941 *Birth of the Blues*, a fictional history of the Original Dixieland Jazz Band, the city's first all-white jazz ensemble, which boastfully but incorrectly claimed to have 'invented' jazz. Renamed the Basin Street Hot-Shots in the film, which was made on a Hollywood soundstage, the band is led by Jeff Lambert (Bing Crosby).

Alex North's original score for Elia Kazan's 1951 *A Streetcar Named Desire* – set in the French Quarter – was nominated for an Academy Award for Best Original Score and is noteworthy for the importance jazz has as part of the unfolding narrative. Yet Streetcar was mostly filmed in Los Angeles, and North's roots were not in the Big Easy but Pennsylvania.

Along with what Krin Gabbard (1996) called the 'unrepressed racism' expressed by *The Birth of the Blues*, several other films about New Orleans jazz reinforce the racism of their era by deliberately denying the crucial contributions, significance, and impact of black musicians to 'elevate the achievements of white musicians over those of blacks'.

William Dieterle's 1942 *Syncopation*, while performing a history of jazz that begins in Africa and New Orleans, ultimately effaces the influence of Crescent City's black jazz musicians

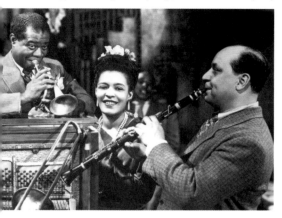

in favour of their white Chicago counterparts whose musical style is deemed preferable: 'the film develops the notion that a white jazz, soon to be called swing, is fundamentally different from the "hot" music of New Orleans [...] swing has totally transcended jazz. Rex (Todd Duncan) and the black musicians had disappeared a good half-hour before the end of the film' (*Jammin' at the Margins: Jazz and the American Cinema* [Krin Gabbard, 1996]).

Closing *Syncopation* is a montage of only white jazz and swing musicians, including Benny Goodman. Lubin's 1947 *New Orleans*, which was filmed in part on location, features not only the music of Louis Armstrong and His Band (who performs, among other classics, 'Do You Know What It Means to Miss New Orleans', 'Farewell to Storyville', and 'Where the Blues were Born in New Orleans') but also Armstrong as an actor.

Although originally meant to be an Armstrong biopic, *New Orleans* relegates Armstrong and Billie Holiday to roles lesser than those of the white protagonists and of jazz musicians such as Woody Herman, whose performance closes the film. As Gabbard (1996) wrote: 'The progress of *New Orleans* from concept to final film is a revealing and dispiriting example of how African Americans fared in the studio system of the 1940s [...] as with as with *Syncopation*, the black artists around whom the film was originally built have been off screen for sometime

> **'The progress of *New Orleans* from concept to final film is a revealing and dispiriting example of how African Americans fared in the studio system of the 1940s**

by the final credits.'

An authentic depiction of New Orleans music in film comes in Louis Malle's controversial but acclaimed *Pretty Baby*, which covers the sordid subjects of child prostitution and paedophilia. Like *New Orleans*, *Pretty Baby*'s context is the 1917 closure of Storyville: filmed on location in New Orleans and Hattiesburg, Mississippi, *Pretty Baby* is set in a high-end brothel.

Central to the film is the historic figure E. J. Bellocq (1873–1949; played by Keith Carradine) whose photographs of Storyville's prostitutes are celebrated. The film depicts Bellocq's interactions with the fictional house's residents, staff and patrons, particularly prostitute Hattie (Susan Sarandon) and her 12-year-old daughter Violet (Brooke Shields).

As previously mentioned, *Pretty Baby* takes its inspiration, as well as title, from the Tony Jackson song. Along with Jelly Roll Morton, Jackson was one of the most popular pianists and singers performing throughout Storyville. A gay African-American, he supposedly wrote 'Pretty Baby' about his blonde, Caucasian male lover.

'Pretty baby' is how Jackson's onscreen surrogate, the brothel's ever-present pianist 'the Professor' (Antonio Fargas), characterizes Hattie's infant son. Yet the film's titular 'pretty baby' is Violet, who is sold into prostitution when her virginity is auctioned to a group of male patrons in a grotesque scene while the Professor – one of the film's few moral compasses – silently observes the proceedings, which disturbingly recall the slave market, a revolting reminder of New Orleans's not-too-distant past.

Pretty Baby's soundtrack was nominated for the Academy Award for Original Music Score (adaptation). It features not only the title song but also many prime examples of New Orleans jazz, blues, and ragtime from the film's epoch by Jelly Roll Morton, Scott Joplin, and The Original Dixieland Jazz Band, among others. To evoke the authenticity of *Pretty Baby*'s New Orleans, the film's music was performed by renowned musicians from the city, such as Louis Barbarin, James Booker, Raymond Burke, Louis Cottrell, Jr., Louis Nelson, and the New Orleans Ragtime Orchestra.

Malle's film is one of the great reminders that, whether recreating the city onscreen through sets or when actually filming there, jazz is not only an important, but also an essential, component of the films of New Orleans. ✢

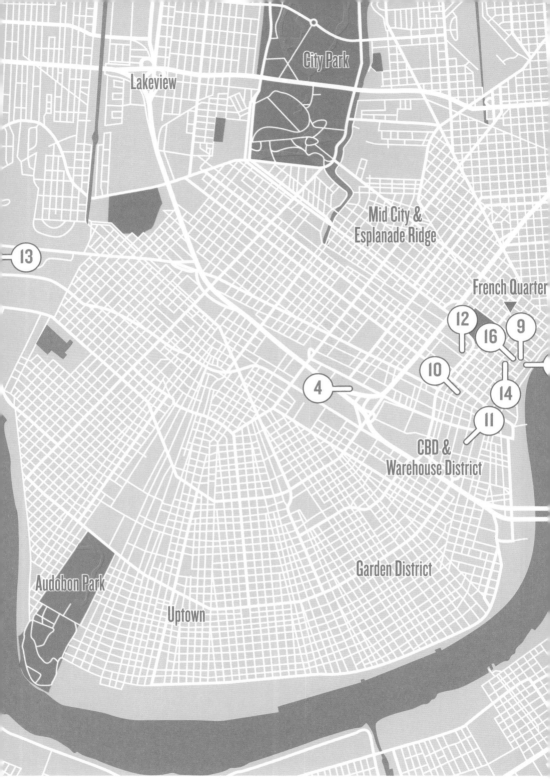

Lakeview

City Park

Mid City &
Esplanade Ridge

French Quarter

13

12

16

9

10

4

14

11

CBD &
Warehouse District

Garden District

Audobon Park

Uptown

NEW ORLEANS LOCATIONS

SCENES 9-16

WALK ON THE WILD SIDE (1962)

LOCATION *913 Chartres Street, LA 70116*

DAYLIGHT ON THE CORNER of Chartres and Dumaine Streets in the French Quarter. An apparently respectable middle-aged man in a grey suit and hat picks up the paper and spots the latest of the daily ads young Dove Linkhorn (Laurence Harvey) has placed while searching for his lost love, Hallie Gerard (Capucine), who is now a prostitute in the up-market Dollhouse. But as the man, Karl Swenson's Schmidt, grabs his metal coshes and spins off on a wheeled board we realize, in a freak show reveal, that he has no legs. He is a low life, literally. The static wide shot of the historic street gives us a rare look down on the closed, stunted world of the whorehouse at 904 Chartres Street (actually filmed at 913 Chartres Street), where we are soon to be trapped. We see Schmidt's wooden capped stumps clearly for the first time as he enters the black door of the Dollhouse and wheels through the grand bar to the office where be-suited madam Jo Courtney sits like an executive as her sadistic enforcer, the handsome Oliver, lurks silently and ominously in a corner, awaiting assignment. Jo mocks the eager Schmidt as a 'retriever dog' as he shows her the paper, their true connection as yet unrevealed. 'He'll get tired of wasting his money,' declares Jo, coldly. 'It's a big city full of lost girls.' Schmidt rages impotently as Oliver jeers. 'Stop it, boys!' Jo tells them, before going up to check on Hallie, her prized possession. •*Samira Ahmed*

(Photo © Gabriel Solomons)

Directed by Edward Dmytryk
Scene description: Welcome to the Dollhouse
Timecode for scene: 0:29:57 – 0:31:23

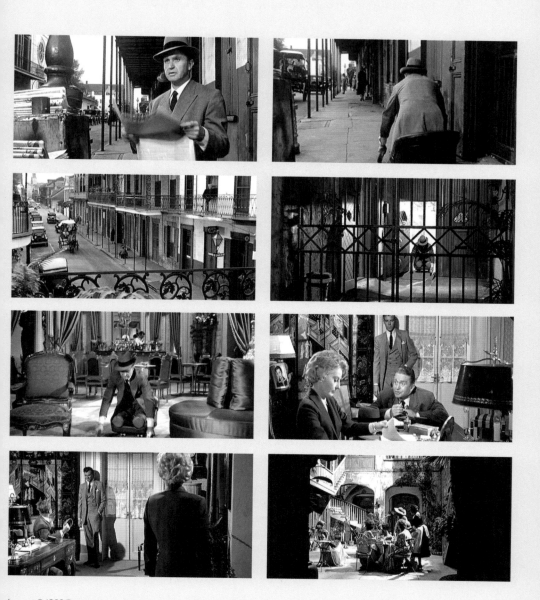

Images © 1962 Famous Artists Productions / Columbia Pictures Corporation

GIRL IN TROUBLE (1963)

LOCATION *The Roosevelt Hotel (previously named The Grunewald Hotel and The Fairmont Hotel), 123 Baronne Street, LA 70112*

FOR A FILM OF SUCH dubious artistic merit, Lee Beale's hysterical sexploitation shocker *Girl in Trouble* features some fine black-and-white shots of 1960s New Orleans – it's just a shame for the city that all of them are associated with sleaze, desperation or sexual violence. Farmer's daughter Judy Collins (Tammy Clarke) yearns to escape her dull small-town life and flees to New Orleans, adopting the name 'Jane Smith' after apparently murdering a man who tried to force himself on her en route. Struggling to find work, she is employed by the owner of a lingerie shop, who soon sends her on a special assignment: privately modelling new stock for a wealthy man in his hotel room. After a long, slow sequence in which both the man and the camera leer as Judy changes outfits, he rapes her. It is an unpleasant scene, its nastiness amplified by the suspicion that, despite the film's over-serious warnings about the plight of young women, it is included simply for the 'entertainment' of the audience. The scene is not one of the prouder moments in the history of its setting: the renowned Roosevelt Hotel, formerly the Louisiana residence of the state's most (in)famous governor, Huey P. Long. But The Roosevelt has survived worse than appearing in a bad taste B-movie. Severely damaged by Hurricane Katrina in 2003, it was forced to close. Now, though, it is a monument to the resilience of the city: it was reopened, to much fanfare, in autumn 2009.
⇝Scott Jordan Harris

(Photo © Gabriel Solomons)

Directed by Lee Beale (AKA Brandon Chase)
Scene description: Rape at the Roosevelt Hotel
Timecode for scene: 0:47:22 – 0:59:54

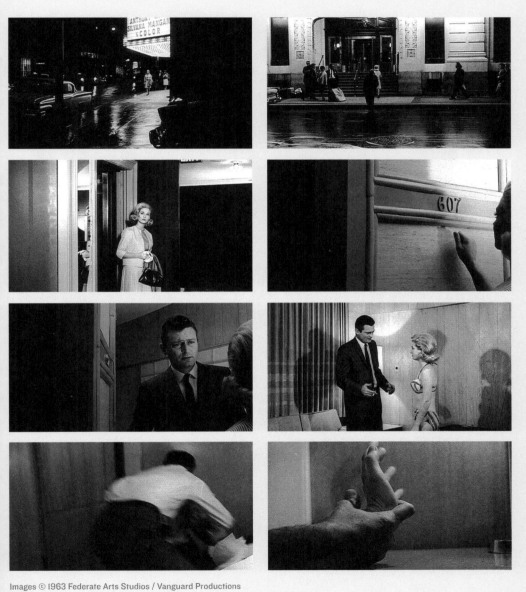

Images © 1963 Federate Arts Studios / Vanguard Productions

THE CINCINNATI KID (1964)

LOCATION *Lafayette Hotel, 600 Saint Charles Avenue, LA 70130*

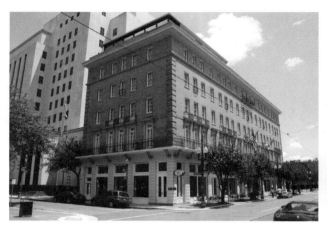
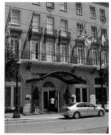

ERIC STONER, aka the Cincinnati Kid (Steve McQueen), has a date with destiny: Monday at 5 pm in room 2A of the Lafayette Hotel. Here he will play the biggest poker game of his life, against Lancey 'The Man' Howard (Edward G. Robinson). The Kid arrives outside the grand entrance to the hotel in a yellow taxi, while inside Lancey waits coolly among a gathering of perspiring players and expectant onlookers. The game is open stakes five-card stud: a high-risk variant of poker brought to New Orleans by French sailors in the 1800s and propagated upstream on the Mississippi riverboats. One by one the other players fold until only the Kid and Lancey remain under the hot, cascading light from the multi-coloured tiffany lamp above the table. Hours pass, the players break and resume several times throughout the night, and by the early hours it appears that the Kid has the upper hand, only to lose dramatically to a straight flush. The Kid has suffered at the Lafayette: having entered a contender, he exits a loser. He leaves dejectedly by the back entrance but turns the corner into the arms of his lover, Christian (Tuesday Weld). The hotel was built in 1916 and, by the 1930s, when the film is set, was regarded as one of New Orleans's finer establishments. Although it was in relative disrepair at the time the exterior shots were filmed for *The Cincinnati Kid*, a major refurbishment in the 1980s returned it to its former opulence. **➻ Jez Conolly**

(Photos © Paul Dowling)

Directed by Norman Jewison
Scene description: The big card game
Timecode for scene: 0:57:03 – 1:41:37

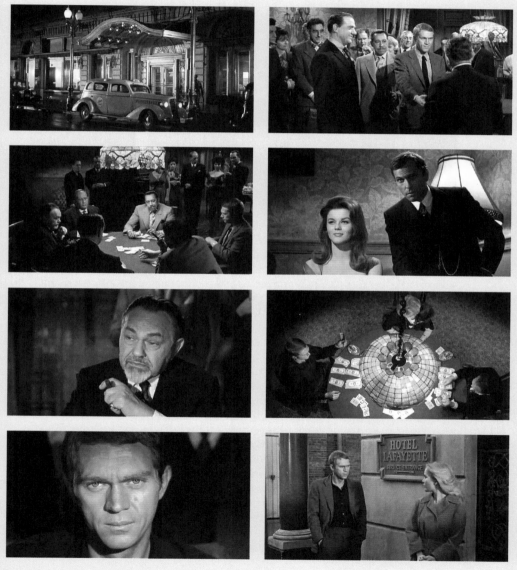

Images © 1964 Metro-Goldwyn-Mayer (MGM) / Filmways Pictures

EASY RIDER (1969)

LOCATION *St Louis Cemetery #1, specifically The Italian Benevolent Tomb, 1300 Saint Louis Street, LA 70112*

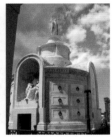

IT IS PERHAPS the worst scene in *Easy Rider* and probably the one that has aged least well but, for those with an interest in New Orleans locations, it is the most memorable. Nearing the end of their counter-cultural odyssey, bikers Billy (Dennis Hopper) and Wyatt (Peter Fonda) are joined by a couple of women and stumble into one of the most famous areas of The Big Easy, the first St Louis Cemetery, to drink and do drugs. Constructed in 1789, the cemetery is the city's oldest and most picturesque, but its sculptural tombs are functional as well as beautiful: early settlers found that buried bodies washed up out of the ground during flooding, and so began to use above-ground tombs. Noted as they are, perhaps nothing has brought the tombs at St Louis Cemetery #1 as much fame as being the backdrop for *Easy Rider*'s strangest sequence. The scene follows the now-standard (but then-shocking) formula for a filmic acid trip: shots are non-linear; images are distorted; and characters cringe, mumble, make love and make odd noises. Particularly prominent is the tallest structure in the cemetery, the Italian Benevolent Society Tomb, which Wyatt climbs. He sits in an alcove, embracing, kissing and crying over a statue, and holding out an umbrella. One wonders what the members of the Italian Benevolent Society made of Fonda's onscreen antics, though perhaps Hopper's off-screen antics bothered them more: locals supposedly maintain that the wild man actor-director decapitated one of the cemetery's statues. **➻ Scott Jordan Harris**

(Photos © Paul Dowling)

Directed by Dennis Hopper

Scene description: Psychedelic sacrilege at the St Louis Cemetery #1

Timecode for scene: 1:18:20 – 1:24:21

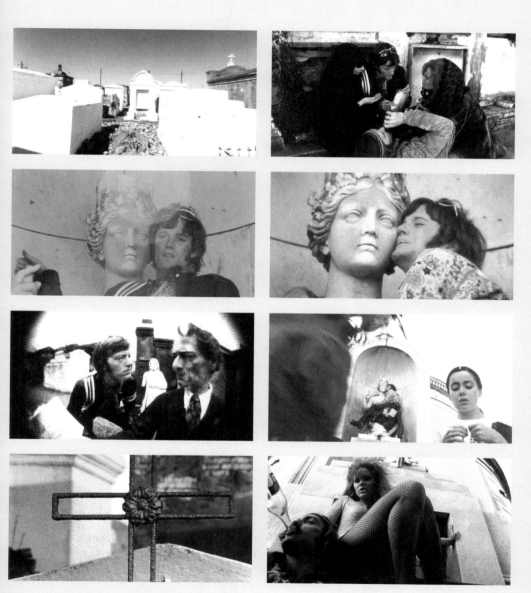

VIOLENT CITY AKA THE FAMILY (1970)

LOCATION *Louis Armstrong New Orleans International Airport, 900 Airline Drive, Kenner, LA 70062*

JEFF HESTON (CHARLES BRONSON) has had an eventful holiday: he's carried out a contract killing, been double-crossed, recovered from two bullet wounds, and somehow been released from prison after being arrested for a triple murder. Now the high-priced hit man is flying back to New Orleans, and arrives – as most international, and many domestic, visitors do – at the New Orleans International Airport. He is met by two heavies who want to hire him, but he refuses their offer. 'Come on,' says one. 'For $50,000 we can have anyone pull the trigger.' To test the theory, Heston catches the attention of the nearest man to him – a surprised, soft-looking gentleman who is probably not a professional murderer – and says, 'This guy has a proposition for you.' While the gangster is stuck talking to the tourist, Heston departs in the car he has arranged to have collect him. It's similar to the scene from *Hard Times* (Walter Hill, 1975) that is featured in this book. In both, Bronson plays a taciturn tough guy whose skills are in demand in New Orleans, but who refuses an offer to profit from them because he prefers to do things his way. And, in both, Bronson manages to be at once intimidating and amusing, saying a great deal with few lines. The city airport is an obvious but effective setting for the scene: it shows that, wherever Heston goes, there are people waiting who either want to do him harm or have him do harm to others. **Scott Jordan Harris**

(Photo © Ken Lund)

Directed by Sergio Sollima
Scene description: 'Welcome back... the boss wants to talk to you'
Timecode for scene: 00:23:28–00:25:01

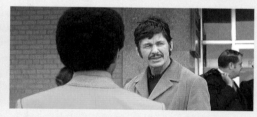
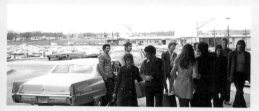
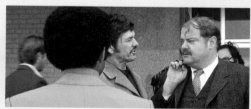
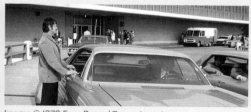
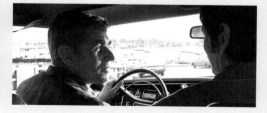

Images © 1970 Fono Roma / Target Associates

WUSA (1970)

Preservation Hall, 726 Saint Peter Street, LA 70130

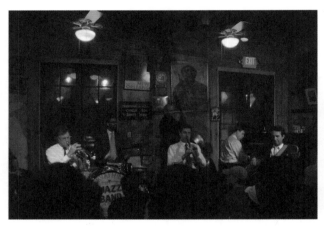

LIKE THE GRADUAL EFFECTS of a Sazerac cocktail, it is slowly dawning on hitherto cynical radio announcer Rheinhardt (Paul Newman) that the editorial policy being pursued by his employers at the radio station WUSA may just make it a tool in the hands of extreme right-wing conspirators. In this scene, we see him sharing a little downtime in the French Quarter home of New Orleans jazz with his lady friend, Geraldine (Joanne Woodward). He's trying to blot out his creeping realization with a flask of booze while listening to the legendary Preservation Hall Jazz Band make their characteristically languid way through a rendition of the traditional gospel song 'Just a Closer Walk with Thee'. It is a song that frequently features during the dirge section of jazz funerals, and its presence here suggests that Rheinhardt is approaching a point of change, equivalent to 'cutting the body loose', the stage in the funeral ceremony when mourners bid farewell to the corpse, after which the music picks up a more raucous, purposeful momentum. The Preservation Hall, just three blocks from the Mississippi, was constructed as a private residence back in 1750, but opened its doors as a music venue in 1961 in a conscious attempt by its founders, Allan and Sandra Jaffe, to preserve New Orleans jazz at a time of mounting competition from modern jazz and rock 'n' roll. This sanctuary setting allows Rheinhardt the time and space to consider where his allegiances lie.
◆Jez Conolly

(Photo, top left © Shane McClellan)

Directed by Stuart Rosenberg
Scene description: 'Just a closer walk with thee'
Timecode for scene: 0:54:12 – 0:56:41

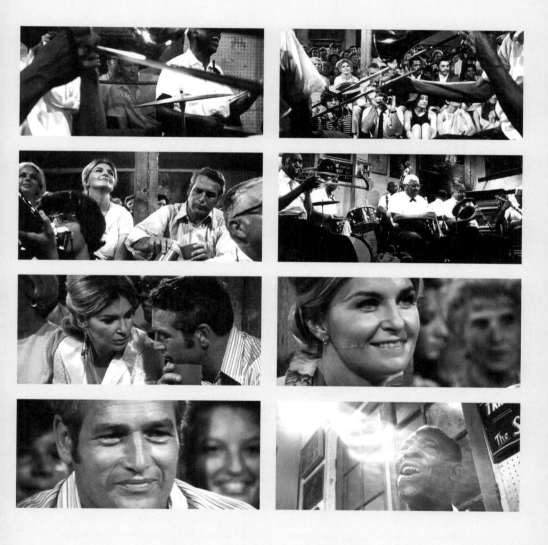

LIVE AND LET DIE (1973)

The junction of Dumaine and Chartres Streets, LA 70116

THE JAMES BOND MOVIES' knack for pastiche puts a macabre spin on New Orleans's carnival spirit in Roger Moore's debut as 007. During the pre-credits sequence, Hamilton (Robert Dix), is one of three British agents murdered on the orders of heroin smuggler Mr Big, aka Dr Kananga (Yaphet Kotto). The spy has Kananga's base of operations in the French Quarter, the bar Fillet of Soul, under surveillance when a street funeral rounds the corner. Dressed in black, the grieving widow and her fellow mourners are accompanied by a brass band playing the lament 'Just a Closer Walk with Thee'. 'Whose funeral is it?' Hamilton asks a passer-by. 'Yours,' the man says, stabbing him to death. As the corpse is discreetly removed into the empty coffin, the mood suddenly lightens. The music shifts from a dirge to the celebratory 'Joe Avery's Piece'; brightly coloured feathers are wielded; and the widow now dances happily. The scene is most notable for the inclusion of the city's fabled Olympia Brass Band. The world-famous troupe had performed in London earlier in 1972 (the year of filming) for the Queen's silver wedding anniversary. Here, though, their intentions towards Britain are deadly, with Hamilton's killer played by the group's trumpeter, Alvin Alcorn. Fillet of Soul's exterior was Sideshow, a curiosity shop at 828 Chartres Street. Hamilton was knifed across the road outside number 837. Ironically, since 1972, official Mardi Gras celebrations no longer enter the French Quarter due to the danger of congestion on its narrow streets. ➻ *Simon Kinnear*

(Photo © Gabriel Solomons)

Directed by Guy Hamilton
Scene description: A British agent is killed by Kananga's henchmen
Timecode for scene: 0:01:57 – 0:03:51

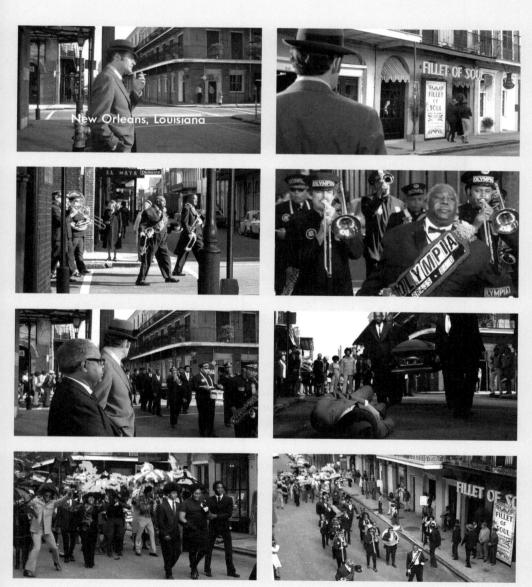

Images © 1973 Eon Productions

MY NAME IS NOBODY (1973)

LOCATION — *905 and 915 Royal Street, LA 70116*

WHEN A TIGHT-LIPPED gunslinger lets slip his city of origin in a western, he's often a disillusioned Southern Rebel. If he's a certain kind of dandy (he'll wear a frilled shirt, smoke a longer cigar, and be more adept at cards), he hails from New Orleans. It's the place desperadoes set out from, not end up. But in *My Name is Nobody*, all conventions are upside down and backwards, and a bustling New Orleans street is the place where Jack Beauregard (Henry Fonda) will be firmly (and fatally) set in the history books by Nobody (Terence Hill). Bizarrely, they have actually travelled east, not west, in order to find the perfect place for their theatrics. The scene is a perfect mockery of Sergio Leone. Jack and Nobody stare one another down too long. The Ennio Morricone score is too shrill. The scenery is all wrong. The quick cuts to Victorian bystanders reveals no tension or bloodlust. Instead, they show only uninterested expressions; they want someone to draw only so they can get on with their shopping. Our gunslingers are utterly alien in this quasi-European city of sophistication, their dusters, spurs, boots, and hats are jarring against lacy ironwork, elegant citizens, horse drawn carriages and river steamships. New Orleans was established long before men ventured west, and it seems to regard these two relics with annoyance. The only one glad to see them is the photographer, who knows history when he sees it, and eagerly documents this last gasp of the Old West. •**Elisabeth Rappe**

(Photo © Gabriel Solomons)

Directed by Tonino Valerii
Scene description: The final showdown between Nobody and Jack Beauregard
Timecode for scene: 1:40:30 – 1:43:30

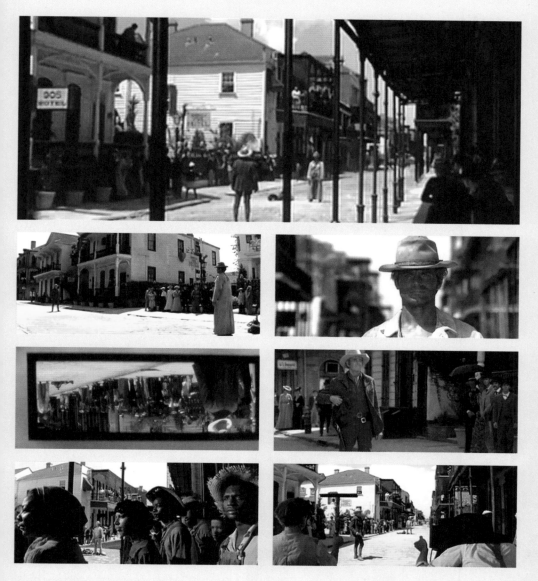

NEW ORLEANS: A SUPERNATURAL CITY

Text by ELISABETH RAPPE

FROM VOODOO TO VAMPIRES, New Orleans has often been the setting for movies with occult themes. The reason for this is simple: in New Orleans, the supernatural and the spiritual are still woven into the texture of everyday life. The majority of American cities have rejected Old World beliefs, but they hang on with a medieval persistence here. Pilgrims flock to the tomb of Marie Laveau, the voodoo Queen of New Orleans, draw the customary Xs, and offer her gifts in hopes she will grant them a wish. Voodoo supply stores are only partly for tourists, and even the city's voodoo museum serves active practitioners. Necropolises dot the city, and psychics and tarot cards can be found on every block of the French Quarter. The local Catholic Church, still a deeply ingrained part of the city, made peace with it long ago.

Because of this, Hollywood has decided that setting a film in New Orleans does all the work of building a weird world. But film-makers have exploited New Orleans voodoo far less than would be expected, instead fixating on creatures of the underworld in the belief that one doesn't need to explain why vampires, werewolves,

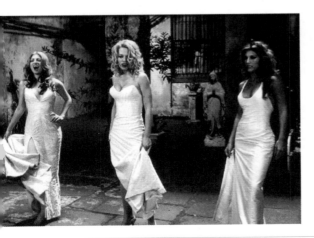

ghosts, or zombies are present in New Orleans. As Paul Schrader enthused, 'New Orleans [...] is one of those towns where you think almost anything can happen – and probably has!' This has led to a lot of lazy horror films, but it's also given rise to a few bits of mythology – mainly themed around Anne Rice and her vampires – that continue to be built upon and referenced in literature, cinema and television.

Of course, New Orleans voodoo has been prominent in numerous Hollywood films – from the horror of *Angel Heart* (Alan Parker, 1987) and *The Skeleton Key* (Ian Softley, 2005) to the reincarnation romance of *French Quarter* (Dennis Krane, 1987) to the whimsy of *The Princess and the Frog* (Ron Clements and John Musker, 2009) – and, while most voodoo films distort the practice, it's worth noting that *Heart* and *Frog* both take pains to distinguish good voodoo from bad. Heart even implies that the worst voodoo – or rather, Satanism cloaked as voodoo – is found only in the city and is practiced by wealthy whites, and is distinct from the pure and good-intentioned version practiced in the poorer boroughs. Though a Disney animation, *Frog* makes no bones about what happens to dark and greedy voodoo doctors, as opposed to the gentle and animal-loving voodoo queen who lives in the bayou.

Much of the credit for New Orleans's unnatural reputation must be given to Anne Rice, whose novel *Interview with the Vampire* kicked off an enduring obsession with New Orleans vampires. Neil Jordan's big screen adaptation of *Interview* (1994) only increased the allure of Rice's sorrowful and aching immortals, and the exotic city they called home. *Interview* is a stifling and morbid film, enhanced by the narrow streets, gas lamps, and damp corners of the city's crumbling French Quarter. New Orleans's uncanny beauty and numerous crypts make it the perfect city for an immortal to

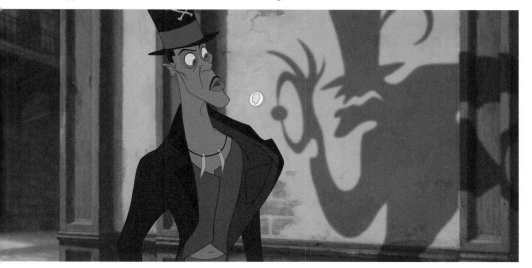

languish, and its notorious nightlife makes blood as easy to obtain as a Hurricane cocktail.

After Rice and Jordan, it became hard to imagine the city without vampires, or that they'd ever choose to live elsewhere. It is an association *Dracula 2000* (Patrick Lussier, 2000) happily exploits, resurrecting the eponymous count in the middle of Mardi Gras, where he could enjoy more than his fair share of virgin (and not so virgin) flesh.

The 1982 remake *Cat People* (Paul Schrader) also banks heavily on the audience's belief that all unearthly creatures are eventually drawn to The Big Easy. Early script drafts attributed the existence of the film's werecats to voodoo, but this was exercised in favour of a vague desert origin. The New Orleans location, however, was kept and the film hints that werecats favour the city because they find recognition and safety in the local religion. Certainly, something about the locale allows the other characters to readily accept that Irena (Nastassja Kinski) is a werecat.

The little-seen *Dylan Dog: Dead of Night* (Kevin Munroe, 2010) relies on New Orleans's place in pop culture for its supernatural adventure. Based on the popular Italian comic, Dylan abandoned the source material's London setting in favour of the no-explanations-really-necessary New Orleans. To the film's credit, its makers are clearly in love with the city and relish every recognisable location shot they can present.

In contrast, Lucio Fulci's *The Beyond* (1981) doesn't rely on its setting for explanation, and has little interest in anchoring its ghosts, zombies, and cursed books to any local phenomenon or history. To the audience it seems natural that one of the film's seven gateways to hell is in a New Orleans hotel, but one suspects the city was interchangeable with Houston or Miami in Fulci's mind. His Hell is an inner horror, and an accursed place can be wherever that inner horror happens. Here it just happens to be in Louisiana.

More often than not, New Orleans' rich and fascinating history is ill-used as a backdrop to poorly scripted horror films, such as *Dracula 2000* or *Candyman: Farewell to the Flesh* (Bill Condon, 1995). Such an evocative city deserves something mature and elegant from the supernatural genre – but perhaps no film can truly compete with the real and alluring magic of the city, and the ghosts and spells that purportedly inhabit it. Sometimes, truth is stranger than fiction, and nowhere is that more evident than the city of New Orleans. ✤

Necropolises dot the city, and psychics and tarot cards can be found on every block of the French Quarter. The local Catholic Church, still a deeply ingrained part of the city, made peace with it long ago.

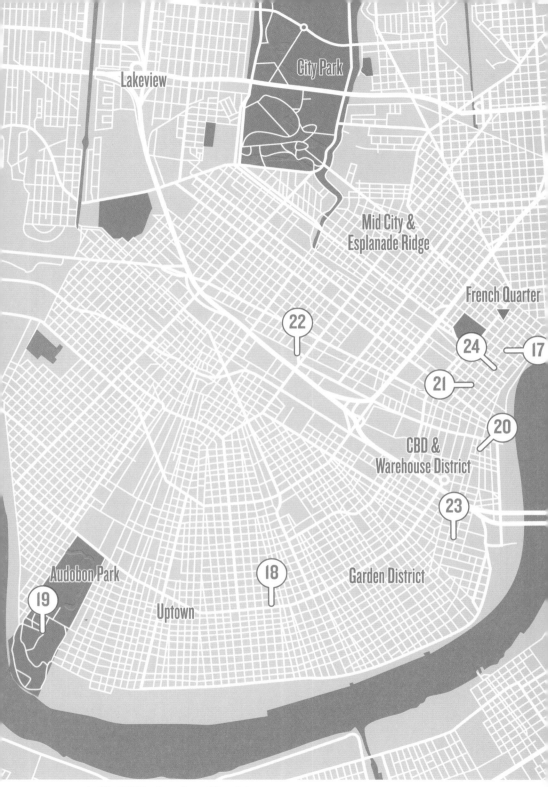

NEW ORLEANS LOCATIONS

SCENES 17-24

HARD TIMES AKA THE STREETFIGHTER (1975)

LOCATION *Cornstalk Hotel, 915 Royal Street, LA 70116*

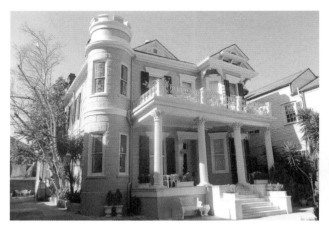
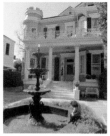

THERE ARE SEVERAL REASONS for the Cornstalk Hotel's fame. There is its unique 'Cornstalk Fence', an orderly iron crop of pumpkins and corn, which is a New Orleans landmark. There is the story, perhaps apocryphal, that Harriet Beecher Stowe was inspired to write *Uncle Tom's Cabin* while staying there. And there are the tales of the ghosts that supposedly haunt it. To film fans, though, the Cornstalk is known as the home of 'Speed' Weed, James Coburn's good-hearted hustler in *Hard Times*. When Chancey (Charles Bronson) arrives, Speed ineffectually orders his 'permanent fiancée' to make breakfast and guides his visitor to the balcony. Speed arranges bare-knuckle boxing and wants to hire Chancey as his 'hitter'; having seen him fight, he knows he is 'tough as a nickel steak'. 'We'll go 50-50 on scratch bets... All side bets, I'll keep 75 per cent,' explains Speed. Chancey is not persuaded. '60-40 in my favour on scratch. Side bets down the middle,' he says, in what seems like the longest sentence he's ever spoken. Speed insists his offer is simply the standard deal. 'We'll do things differently,' says Chancey. Beneath them is the French Quarter, and its exotic atmosphere is ill-fitting with Chancey's joyless manner and the brutal business he is arranging. Just as he is un-swayed by Speed's attempts to con him, he is immune to the city's appeal. This scene announces he will not be corrupted or seduced by The Big Easy – because he is a man who does things differently. ◆ *Scott Jordan Harris*

(Photos © Gabriel Solomons)

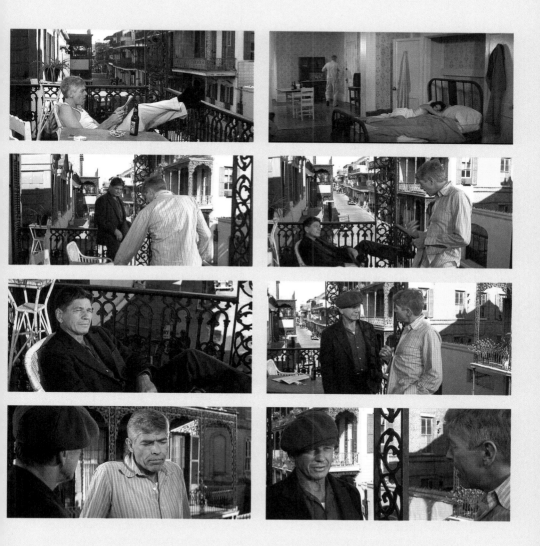

PRETTY BABY (1978)

Columns Hotel, 3811 Saint Charles Avenue, LA 70115

LOUIS MALLE'S EVOCATIVE PORTRAIT of New Orleans in 1917 during its final days of legal prostitution remains an unsettling and controversial film. Generally well-received but criticised for including nude shots of the then-preteen Brooke Shields in her contentious role as the illegal child prostitute Violet, Malle's film is rich in period detail and unstinting in its depiction of the debauchery of Storyville, then the Big Easy's red light district. Set largely within the elegant confines of a brothel run by the aging Madame Nell (Frances Faye), *Pretty Baby* contains one particularly distasteful sequence in which 12-year-old Violet has her virginity auctioned off after being paraded around the house for all to see. Surrounded by opulent interiors, wealthy patrons and concerned onlookers, Violet, described by Nell as 'the finest delicacy New Orleans has to offer', is sold to the highest bidder like cattle or, as is heavily implied, a Negro slave. Filming for *Pretty Baby*'s brothel sequences took place in the Columns Hotel on Saint Charles Avenue in the city's Garden District. Built as a residence in 1883 and designed by architect Thomas Sully, famous for a number of the city's buildings, the Columns Hotel is the only Italianate house Sully designed that is still standing. One of the finest remaining examples of turn of the century Louisiana architecture, the Columns Hotel was the perfect choice to represent one of the Storyville era's many architecturally similar brothels. •**Neil Mitchell**

(Photo © Gabriel Solomons)

Directed by Louis Malle
Scene description: The auction for Violet's virginity
Timecode for scene: 0:46:00 – 0:51:25

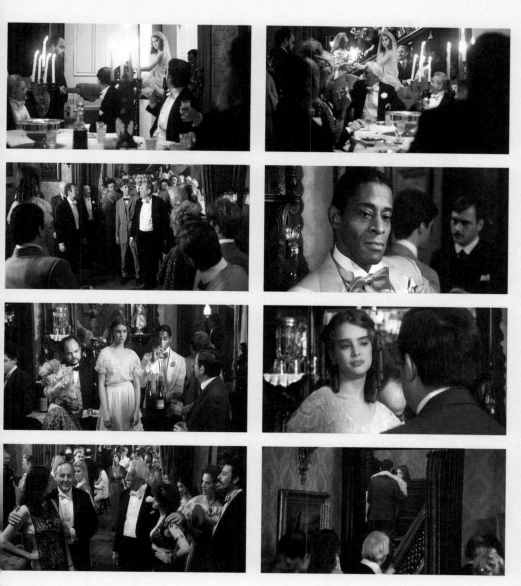

CAT PEOPLE (1982)

LOCATION *Audubon Zoo, 6500 Magazine Street, LA 70118*

WELCOME TO THE AUDUBON ZOO – or is it? That's the question when it comes to Paul Schrader's version of *Cat People*, because, let's face it, few visitors to the zoo nowadays will recognise what they see in this film. Part of the reason is that the Audubon has been largely reconstructed since Schrader filmed there in the early 1980s. But mostly it's because he also used an elaborate, gothic set as a stand-in for many scenes, on the grounds that, 'You have to have such total control of the environment that, in the end, you had to build a zoo, or buy out a zoo – and it was cheaper to build one.' So the zoo in the film is actually a mixture of the old Audubon and the Hollywood set, often stitched together with matte paintings. In other words, a cinematic trick. But don't feel conned by it: this juxtaposition of real and fake is deliciously apt for a film that, in a way, is all about juxtapositions: of old and new, lust and love, the fairytale and the everyday. And it builds a background sense of authenticity into some of the film's more lurid scenes, such as when Ed Begley Jr.'s zookeeper gets his arm torn off, its bone exposed, by a leopard. Blood flows out everywhere across the white floor of the set. Or is it the white floor of the zoo? **⟶Peter Hoskin**

(Photo © Becca Martin)

Directed by Paul Schrader
Scene description: *A zookeeper attacked*
Timecode for scene: *0:41:09 – 0:43:20*

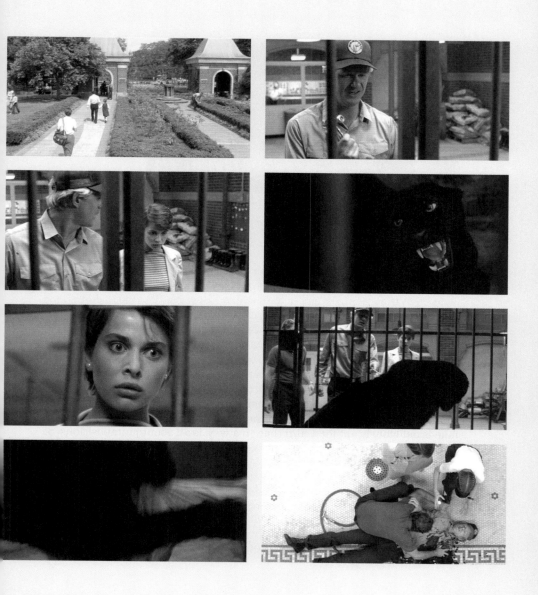

TIGHTROPE (1984)

Piazza d'Italia, corner of Lafayette and Commerce streets, LA 70130

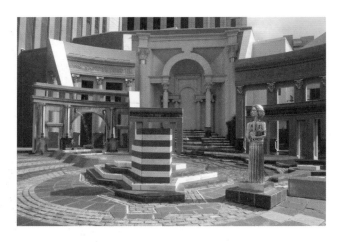

TIGHTROPE WAS A SEEDY DEPARTURE for Clint Eastwood. His past anti-heroes were virile and inclined towards casual sex, but none of them had been drawn into bondage as easily as Detective Wes Block. Reeling from a divorce and the demands of single parenthood, Block is put on the trail of a serial killer, and finds himself pulled further into a world where pain and pleasure are a mere transaction away. When the killer begins targeting Block's partners, the detective begins to fear he may lose everything: his family, his career, and possibly even his freedom. Block faces his peril at the lurid Piazza d'Italia, where the killer has left the body of the popsicle-sucking blonde who was last seen in Block's bed. Tied to one of the Roman statues is another complicating clue: Block's tie, previously used in a bondage game the detective played with another lady of the night. It's a coy link between victim and cop, kink and killer. The implications of its presence drain the colour from Block's face, which is grey beneath the bright neon of the Piazza. The Piazza is a deliciously symbolic place for such a grisly gift. Its flamboyant reinterpretations of Renaissance style clash with the city's French Creole architecture, and a failure to maintain the Piazza led to it being labelled the first postmodern ruin. That label could easily be applied to Block, whose life is crumbling under his lusts, and whose taut figure is comically out of place in the flesh markets he frequents.
➼Elisabeth Rappe

Directed by Richard Tuggle
Scene description: Detective Block discovers a body at the Piazza d'Italia
Timecode for scene: 1:05:47 – 1:07:03

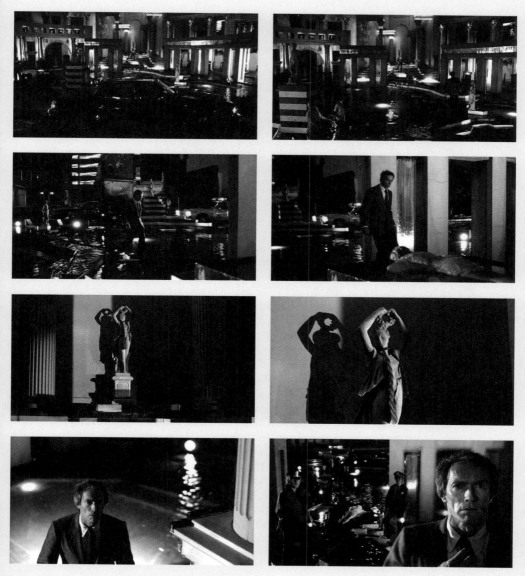

THE BIG EASY (1986)

LOCATION *New Orleans Police Department, French Quarter 8th District Police Station, 334 Royal Street, LA 70130*

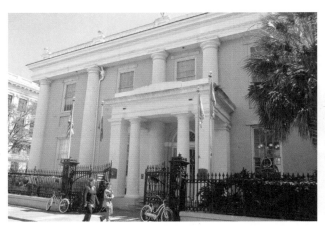

NEW ORLEANS CULTURE is showcased throughout *The Big Easy*. Alongside the positive sides (Cajun cuisine, slang and music) are the negative sides (violence, racial segregation, and clashes between different ethnic and social groups). According to Lieutenant Remy McSwain (Dennis Quaid), 'This is the Big Easy: folks have a certain way of doing things down here.' The city's dangers are exacerbated by police corruption, which is tackled by newcomer Assistant District Attorney Anne Osborne (Ellen Barkin). Although the film features the city's historic neighbourhoods (including slums), iconic landmarks (Antoine's, Tipitina's and the Piazza d'Italia) and breathtaking shoreline, the French Quarter's 8th District Police Station – originally built in 1826 as the Old Bank of Louisiana – is central to the narrative, as it is where Anne and Remy uncover the evidence linking police squad members to several drug-related murders. While there is 'a certain way of doing things' in the Big Easy, Anne and Remy defy that system. In raiding the police department, they upset its balance of power, prevailing hierarchies and customs, much to the shock of the desk sergeant. When Anne presents him with a search warrant, he invokes New Orleans's cultural identity by retorting, 'What do I look like, the King of Mardi Gras?' When Detective DeSoto (John Goodman) reluctantly turns over his personal weapons cache, his words are lighthearted ('It's a jungle out there!') but their menacing edge foreshadows the extent of his criminality. He thinks the law doesn't apply to him – after all, this is the Big Easy. **➻ Marcelline Blocks**

(Photo © Gabriel Solomons)

Directed by Jim McBride

Scene description: Anne and Remy search the police station

Timecode for scene: 1:13:45 – 1:15:44

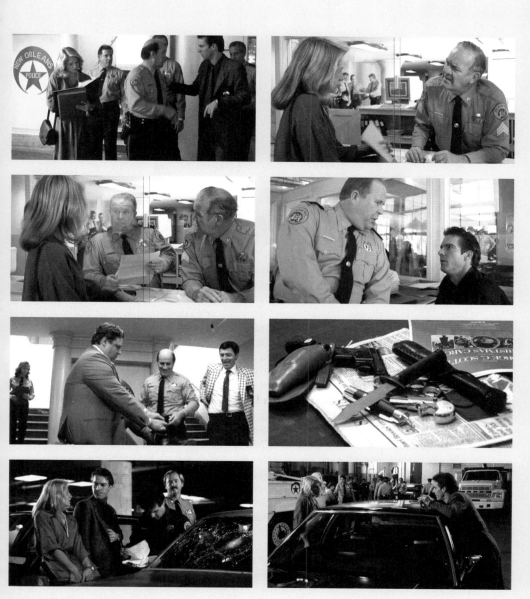

DOWN BY LAW (1986)

LOCATION *OPP Orleans Paris Prison, 2800 Gravier Street, LA 70119*

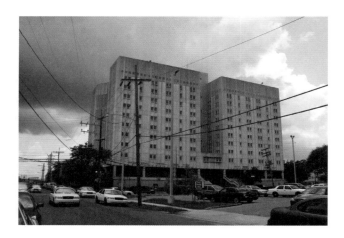

BARS, BARS, BARS. Jim Jarmusch introduces us to the inhabitants of Orleans Parish Prison with a languorous tracking shot along its cells and through its steel bars, until we alight upon a cell where the camera will remain, more or less, for the next thirty minutes of our time. It's a wry counterpoint to the very first shots of the film, which track through the open roads and byways of New Orleans. That was freedom; this is capture. We're stuck in there just as much as the incarcerated main characters are. Only there's a crucial difference between our experience and theirs. For them, this prison cell is almost a temple to boredom: a grey rectangle of a room, made even greyer by the black-and-white photography, with the passing days, weeks and months scratched in to the wall. But for us the experience is a treat. Here are three funny men – a DJ, a pimp and, well, an Italian, played by Tom Waits, John Lurie and Roberto Benigni – stripped down to their essential characters and forced to get along with one another. And we have a ringside seat. 'I scream, you scream, we all scream for ice cream,' they chant just to have something to do. But we know the truth of it: they're slowly building up a weird sort of friendship that might serve them well, if only they could escape... ↝ **Peter Hoskin**

(Photo © Paul Dowling)

Directed by Jim Jarmusch
Scene description: 'A temple to boredom'
Timecode for scene: 0:31-30 – 0:56:12

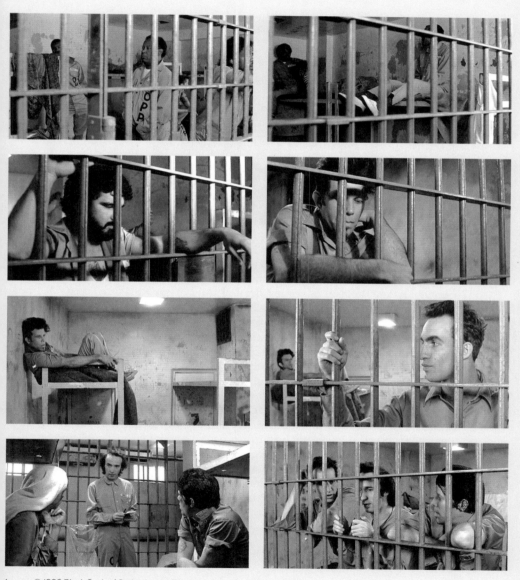

Images © 1986 Black Snake / Grokenberger Film Produktion / Island Pictures

ANGEL HEART (1987)

LOCATION

Saint Alphonsus Church, Constance Street, LA 70130

ALAN PARKER MAKES much of the imposing beauty of the Saint Alphonsus Church. His camera lingers on its stained glass, exquisite altar, and equally exquisite architecture before dishevelled detective Harry Angel (Mickey Rourke) finally enters, and walks to a pew towards the back. There, neat and unnerving, sits Louis Cyphre (Robert De Niro), the mysterious man who hired Angel to search for a singer who has reneged on the kind of deal it is best to honour. Angel tries to shock Cyphre with talk of uncovering murders and the black arts but Cyphre, it seems, is not a man who is shocked by such subjects. 'Who the f—k are you, Cyphre?' asks Angel; Cyphre merely warns him about using foul language in the house of Lord. It's a strange scene for first-time viewers – verbally recapping plot points they have already seen played out – but, for those viewing the film a second time, it is riveting. Once the question of Cyphre's identity has been answered, the church setting becomes charged with significance. Saint Alphonsus was built in 1855 to serve the spiritual needs of Irish Catholic immigrants. It fell into disuse by the end 1970s and has now been reborn as the St Alphonsus Art and Cultural Center, and so still feeds the souls of New Orleans natives. It is unclear, though, what its more devout visitors make of the eerie film in which it hosts a meeting between a man named Angel and one named Lou Cyphre. **•❖Scott Jordan Harris**

(Photos © Gabriel Solomons)

Directed by Alan Parker
Scene description: An unholy heart to heart
Timecode for scene: 1:15:47 – 1:19:50

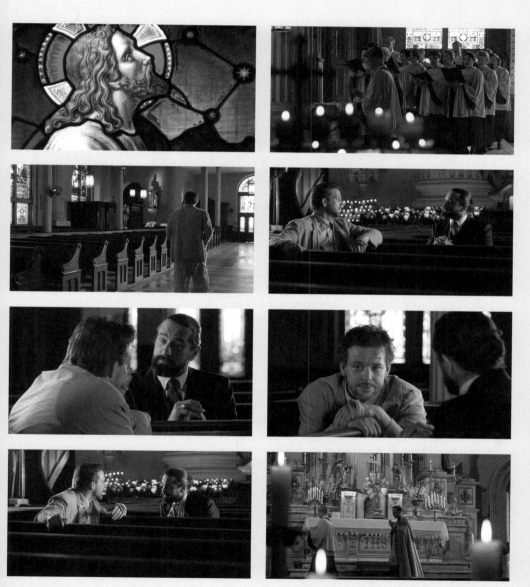

ALL DOGS GO TO HEAVEN (1989)

LOCATION *(An animated version of)* The French Quarter, LA 70116

IN THE GRAND TRADITION of animated animal movies, *All Dogs Go to Heaven* is a musical cartoon aimed at children but featuring some dark adult themes. In a scene that moves from dirty dealings to famous festivities, a paw shake seals the death of canine Charlie B. Barkin's (Burt Reynolds) when a rival bulldog orders him killed. The camera zooms out from the shady shipyard where the deal takes place and pans across water, where we see fireworks explode across the New Orleans sky. In the city, we're treated to a dog's-eye-view of Mardi Gras celebrations, as the welcoming homes of the French Quarter are lit up in purples and greens. Lanterns float across the sky as a parade passes. Blocking our view are the French Quarter's human residents, most of whom we'll never meet, as only a handful of people – including Anne-Marie (Judith Barsi), a pre-school orphan – become central to the story. Beads are tossed from colourful floats as exotic party music plays. Meanwhile, at calf-level, the ever-loyal Itchy Itchiford (brought to life by the voice of comedian Dom DeLuise) weaves between dancing feet to send word to his best pal, Charlie, that he's been double-crossed. This short scene only gives us a flavour of the lives of humans in New Orleans, and of the true nature of the revelries that are underway within it. Far from the casino halls and rat races enjoyed by our story's stars, the dogs of the underworld find their fun in dark abandoned spaces. •➙*Nicola Balkind*

(Photo © Julia Jenkins)

Directed by Don Bluth, with Gary Goldman and Dan Kuenster
Scene description: A dog's-eye-view of Mardi Gras
Timecode for scene: 0:11:15 – 0:11:40

Images © 1989 Goldcrest Films International

EASY DOES IT

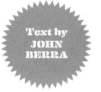

Text by
JOHN
BERRA

Mapping the Moral Lapses of New Orleans Noir

IN THE NEW ORLEANS NOIR *Tightrope* (Richard Tuggle, 1984), Detective Wes Block (Clint Eastwood) recalls his arrival in the city almost three decades earlier:

Twenty-eight years ago I borrowed $40 from my father, packed up an old, beat up suitcase, took a bus and came here. I was seventeen at the time. While I walked through the French Quarter, I looked out over the Mississippi and swore I'd never leave.

When love interest Beryl Thibodeaux (Geneviève Bujold) asks Block if he has ever considered relocating, he replies, 'Only once. When I looked down and saw that the suitcase was missing.'

It's an exchange that effectively summarises the role of New Orleans in the noir genre as a city that combines whisky-soaked romanticism with criminal threat. Stories of shady characters from both sides of the law travel from city hall to the surrounding swamps, with Bourbon Street positioned somewhere in-between as a meeting point for morally-flexible players in

games of money, sex and revenge. The sweaty New Orleans atmosphere was superbly utilised during the classic period of Hollywood film noir as the setting for *Panic in the Streets* (Elia Kazan, 1950); a military doctor (Richard Widmark) and a police captain (Paul Douglas) have two days to prevent an epidemic of pneumonic plague when the body of a homicide victim is found to have high levels of bacteria. This involves meeting with the mayor's office, chasing a lead around the city's Greek restaurants, and a climactic shoot-out at a waterside warehouse, thereby establishing regional genre tropes.

However, New Orleans would not become a noir fixture until the 1980s, when characteristics of the city coincided with the style-conscious commercial cinema of the era: danger, decadence, sexually-charged relationships, and eclectic soundtracks that combined sultry jazz with Cajun rock. *Tightrope* finds the divorced Detective Block dealing with loneliness by visiting the sleazy strip clubs of Storyville, the red light district of the city located on the edge of the French Quarter. When it becomes apparent that Block and the murderer may share the same haunts, comparisons are drawn between cop and killer; Block visits the brothel where one of the victims worked and engages in oral sex with a prostitute, coming close to choking her with his necktie. Block is sexually corruptible, but Lieutenant Remy McSwain (Dennis Quaid) in *The Big Easy* (Jim McBride, 1987) prefers the financial perks of police work, such as taking bribes and not paying for meals in restaurants. The police station is as much of a crime scene as any back alley, although Remy just regards such activity as a time-honoured part of New Orleans life. While charming district attorney Anne Osborne (Ellen Barkin), who is seeking to make a corruption case against local law

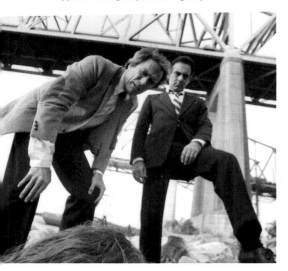

enforcement, Remy explains, 'This is the Big Easy. Folks have a certain way o' doin' things down here.' Remy's easy-going attitude is reflected in the location choices, which include the nightclubs Antoine's and Tipitina's, while the film opens with a sweeping aerial shot of the bayou.

If the cops in *Tightrope* and *The Big Easy* are, respectively, a transplant and a native, then the vengeance-seeking officer of *No Mercy* (Richard Pearce, 1986) is an outsider. Chicago cop Eddie Jillette (Richard Gere) heads down to New Orleans to take revenge on French gangster Losado (Jeroen Krabbé) who has murdered his partner; this results in a chase through the Louisiana bayous with Jilette handcuffed to his quarry's glamorous girlfriend Michel (Kim Basinger). The swamplands prove to be more dangerous than the city streets as Jilette navigates unfamiliar terrain to evade the Losado's henchmen. *No Mercy* is not the only thriller to cast New Orleans as a hunting ground for vengeance as

> **New Orleans would not become a noir fixture until the 1980s, when characteristics of the city coincided with the style-conscious commercial cinema of the era: danger, decadence, sexually-charged relationships, and eclectic soundtracks that combined sultry jazz with Cajun rock.**

Johnny Handsome (Walter Hill, 1989) also deals with a professional who is out to settle a personal score. John Sedley (Mickey Rourke) is a disfigured crook who is apprehended for a jewellery store heist that leaves his best friend Mikey dead due to a double-cross. While serving time in the Louisiana State Prison, John is placed in a rehabilitation programme that rebuilds his face and leads to parole, but despite securing a job at the Avondale Shipyard, the 'reformed' crook wants to take revenge on the criminal couple (Lance Henriksen and Ellen Barkin) that murdered Mikey. His plan involves another robbery and concludes with a shoot-out in the Saint Louis Cemetery where all concerned meet their maker.

Family ties feature as strongly in New Orleans noir as the thirst for blood. *Storyville* (Mark Frost, 1992) follows Cray Fowler, a young candidate for the Senate, who is distracted from his political campaign by a prostitute, resulting in a dalliance in the French Quarter and a potentially scandalous sex tape. Trapped in a blackmail plot, Cray investigates a web of corruption that involves his well-connected father (Jason Robards), realising that: 'The past isn't dead. In fact, it isn't even past.' Although largely set in the world of high society, the titular reference to the red light district serves to link two sides of New Orleans, while these worlds violently collide in a climactic courtroom shoot-out that is settled by a no-nonsense judge who keeps a firearm at his bench. If the protagonist of *Storyville* keeps his indiscretions to a certain part of town, Detective Terence McDonagh (Nicolas Cage) in *Bad Lieutenant: Port of Call – New Orleans* (Werner Herzog, 2009) has no qualms about engaging in bad behaviour all over the city as he racks-up gambling debts and takes drugs while trying to solve a murder case in the aftermath of Katrina. McDonagh is obviously unfit for active duty, but the fact that his father previously served in the same department is sufficient for him to receive the benefit of the doubt.

Due to its gothic romanticism, New Orleans noir has a melancholy quality that distinguishes such melodramas from those that occur in other American cities. Yet it is also steeped in an omnipresent menace that makes the crime stories set in its various districts uniquely suspenseful. ✢

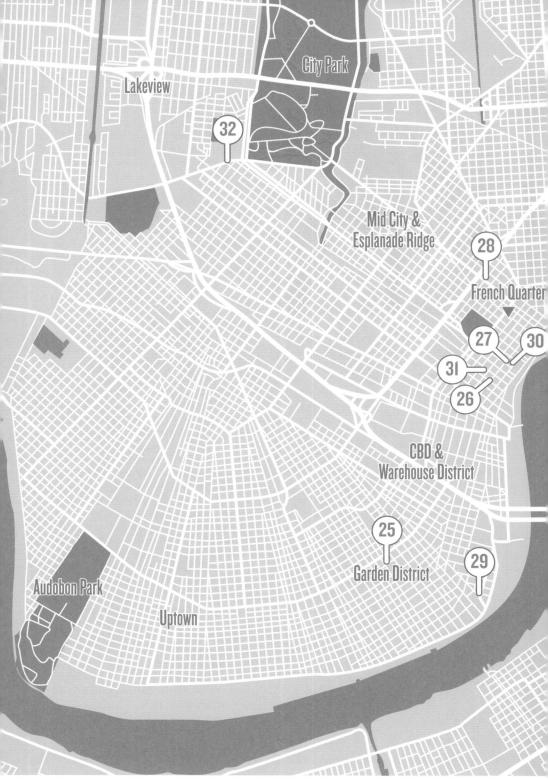

Lakeview

City Park

32

Mid City &
Esplanade Ridge

28

French Quarter

27 30

31

26

CBD &
Warehouse District

25

Garden District

29

Audobon Park

Uptown

NEW ORLEANS LOCATIONS

SCENES 25-32

MILLER'S CROSSING (1990)

Louise S. McGehee School, 2343 Prytania Street, LA 70130

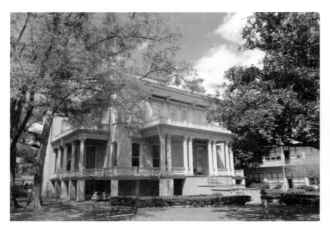

THE GARDEN DISTRICT'S Louise S. McGehee School for girls is famously exclusive, particularly for film crews: until the Coen Brothers' filmed there, it had never been used as a movie location. Despite the film's arresting violence and complex plot, *Miller's Crossing* is chiefly notable for the sumptuousness of its interiors – which is why the Louise S. McGeehee School was cast in a cameo. Its elegant foyer and front door appear as those of the splendid house owned by dyspeptic mob boss Johnny Caspar (Jon Polito) who, as if to emphasise the opulence of his lifestyle, has them patrolled not by a broken-nosed bodyguard but by a butler in morning dress. When Tom Reagan (Gabriel Byrne) arrives, we are not totally sure what his motivation is – because we are never totally sure what his motivation is. He is, it seems, as adept at playing criminal gangs against each other as the heroes of *Yojimbo* (Akira Kurosawa, 1961) and *A Fistful of Dollars* (Sergio Leone, 1963). We do know, though, that is he trying to engineer the downfall of Caspar's second-in-command, Eddie Dane (J. E. Freeman). Reagan starts talking as soon as Caspar appears, saying he has just spoken to a man we know to be dead and heard proof that Dane is a double-crosser. The meeting that follows in Caspar's office would be easier for Reagan if Dane wasn't waiting for him – but I won't discuss that scene here: as Reagan and Caspar leave the foyer, the film leaves the Louise S. McGeehee School.
➩ *Scott Jordan Harris*

(Photos © Gabriel Solomons)

Directed by Joel Coen
Scene description: Paying a call to Caspar
Time code: 1:28:51 – 1:29:36

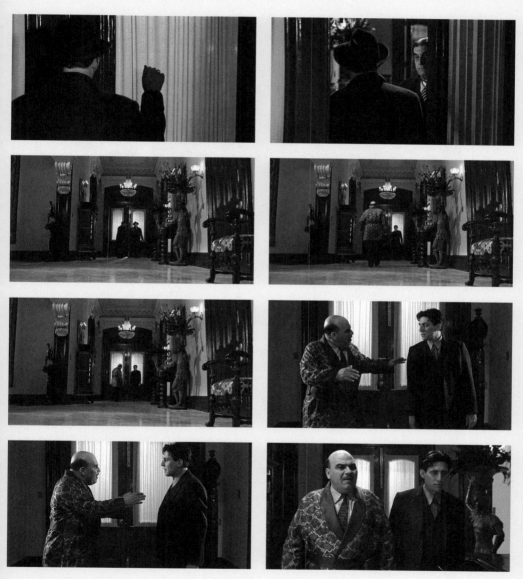

JFK (1991)

The Napoleon House Bar & Café, 500 Chartres Street, LA 70130

KEVIN COSTNER'S JIM GARRISON, the New Orleans district attorney who will go on to prosecute those he believes conspired to kill JFK, is in his office when he learns the president has been shot. 'Napoleon's has a TV set,' he says, and the scene soon switches there – to the Napoleon House Bar and Café on Chartres Street in the French Quarter – where he and, it seems, a large portion of the population of New Orleans watch the news. The television shows CBS, the film reusing the network's actual footage. The drinkers struggle to accept the news of their president's death. Some cry, others sigh, one is glad and begins to applaud. Silent, Garrison stares at the TV – and we see something being born in his mind. Garrison may have chosen Napoleon's just because it had a TV, but Oliver Stone clearly chose it because it screams New Orleans. (Indeed, a promotional video claims 'the Napoleon House is New Orleans.') The building is as handsome, and as famous, as any in the city and is fittingly designated a national landmark. Its history adds to its atmosphere: it was originally owned by Nicholas Girod, who was elected mayor of the city in 1812 and offered the house to Napoleon during the emperor's exile. Napoleon never stayed there, but his name did, and now 'his' bar is one of the city's must-visit venues, whether you want to eat gumbo or drink Pimm's, to host a function, or simply to watch the television news. ✢*Scott Jordan Harris*

(Photos © Gabriel Solomons)

Directed by Oliver Stone
Scene description: Jim Garrison watches the news
Timecode for scene: 0:08:45 – 0:12:26

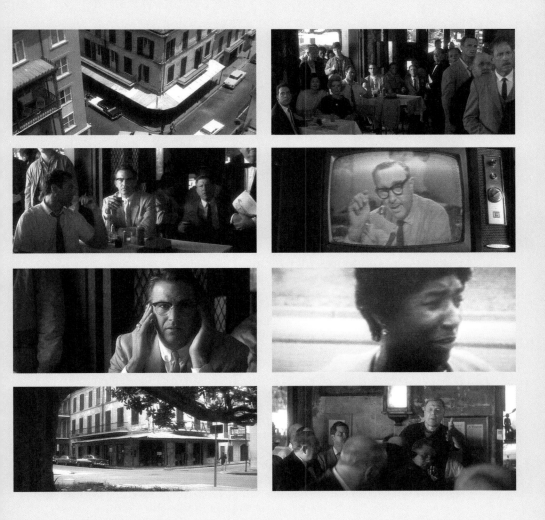

THE PELICAN BRIEF (1993)

LOCATION *St. Anthony's Garden behind The Cathedral-Basilica of St. Louis King of France (St. Louis Cathedral), 615 Pere Antoine Aly, LA 70116*

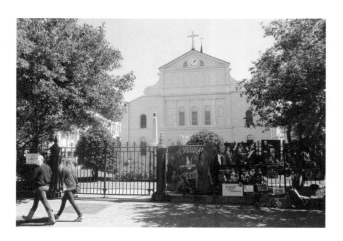

BEFORE JULIA ROBERTS won the 2001 Best Actress Oscar for her portrayal of environmentalist Erin Brockovich, she performed a similar role: fictitious Tulane law student Darby Shaw in *The Pelican Brief*. In this legal thriller, Darby is entangled in a lethal web after discovering that the assassinations of two Supreme Court justices are linked to an oil tycoon seeking to drill in the Louisiana wetlands. Her boyfriend, Professor Thomas Callahan (Sam Shepard), dies in a car bomb planted for her. Darby foregoes Callahan's funeral, asking classmate Alice (Cynthia Nixon) to disseminate a false story about her whereabouts. The Cathedral-Basilica of St Louis King of France – the oldest continually operating cathedral in North America –is one of New Orleans's most prominent landmarks; its founding in 1720 evokes the region's French heritage, further endorsed by this scene's haunting score, François Couperin's sacred choral work 'Troisième Leçon De Ténèbres à 2 Voix', originally composed for Holy Week in 1714 at the Abbaye royale de Longchamp near Paris. Although in the heart of the French Quarter, the sun-dappled green space of St Anthony's Garden contrasts with earlier scenes set in this neighbourhood, in which assassins chased Darby through its rowdy streets. Yet beneath the garden's tranquil veneer of thick trees and twittering birds, violence is lurking: the same thugs hunt Darby amidst Callahan's mourners. From behind the windowpane of a house facing the garden, a disguised and tearful Darby watches the funeral-goers depart, reminding her that this funeral could have been hers. **➔Marcelline Block**

(Photo © Gabriel Solomons)

Directed by Alan J. Pakula
Scene description: Darby misses Callahan's funeral.
Timecode for scene: 0:56:18 – 0:57:11

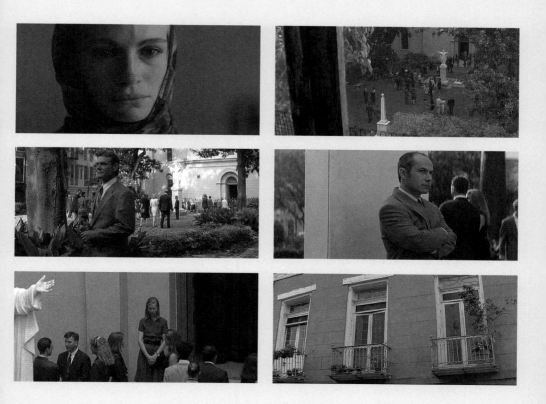

INTERVIEW WITH THE VAMPIRE (1994)

LOCATION *The Marsoudet-Caruso House, 1519 Esplanade Avenue, LA 70116*

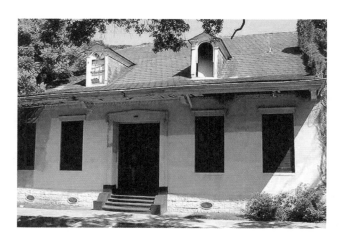

'**AND THEN ON PRYTANIA STREET**, only blocks from the Lafayette Cemetary, I caught the scent of death. And it wasn't coming from the graves...' Though the smell of 'old death' is allegedly too faint for mortal noses to detect, it seeps through the screen just fine as the vampire Louis (Brad Pitt) calmly enters a decaying, overgrown New Orleans mansion. He follows the corpses of rats, laid out like limp breadcrumbs, and discovers his maker, the vampire Lestat (Tom Cruise), huddled in a rotten armchair. They haven't seen one another for 200 years, but Lestat doesn't even need to turn around to know his 'beautiful Louis' has returned. The centuries have not been kind to Lestat. After being burned by Louis and the child vampire Claudia, he has crawled around the underbelly of the city, surviving on what blood he can find. He resembles the decrepit mansion itself: rotted lace and velvet hang off his emaciated and scarred frame. The reunion is interrupted by the searchlight of a helicopter, causing Lestat to panic. The modern world terrifies him, and he begs Louis to stay so he might adapt and become 'the old Lestat'. But Louis leaves, and the last we see of Lestat is his skeletal face sinking back into his armchair, an immortal out of time, forever lost. It is a tragic and repellent scene, and Southern Gothic at its finest, evoking the smell of New Orleans's magnolia and jasmine – a scent Louis longingly describes as a 'long-lost perfume'. **➻ Elisabeth Rappe**

Directed by Neil Jordan
Scene description: 200 years after they last parted, Louis discovers Lestat
Timecode for scene: 1:43:12 – 1:47:48

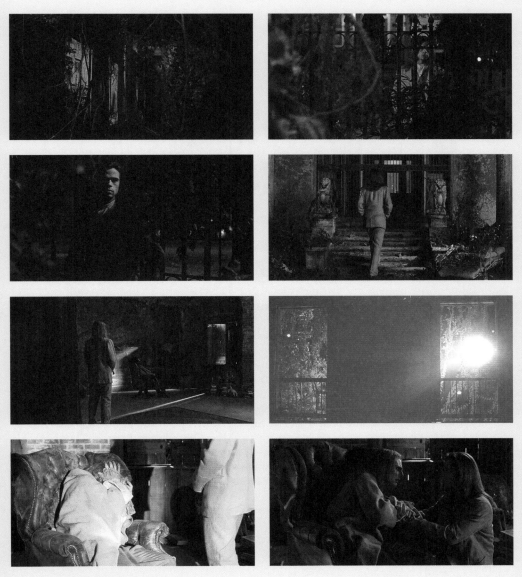

DEAD MAN WALKING (1995)

LOCATION *St Thomas Housing Development, LA 70130*

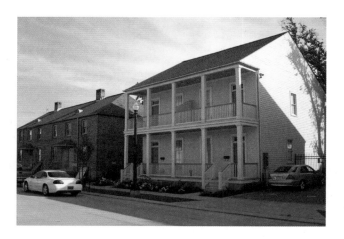

BEFORE THE OPENING CREDITS have ended, we are shown three narrative strands. In one, Susan Sarandon's Sister Helen Prejean drives towards Louisiana State Prison. In another, a girl (presumably Prejean in her youth) is seen at her ordination as a nun. The last shows Prejean walking, living, and working among the poor of New Orleans's St Thomas Housing Development. We see her enter Hope House on St Andrew Street and assist some disadvantaged students. We watch her learn of a death row inmate who has written to her, and see her write back, and we realise it is he that, in the intercut scenes, she is driving to visit. Perhaps no scene featured in this book seems as authentic as this one. The real-life Sister Helen Prejean lived and worked in the St Thomas Housing Projects, and specifically at Hope House. Furthermore, *Dead Man Walking* is based on a book by her. Consequently, seeing these opening scenes, we feel not like we are watching a drama but like we are seeing reality recreated. Though the residents onscreen seem happy, in the 1980s, when the film is set, St Thomas was one of the most wretched areas of Louisiana, if not America. A year after the film's release, the process of demolishing the development's buildings and relocating its residents began. The site now hosts the more welcoming River Garden neighbourhood, but Hope House still stands – existing, as per its mission statement, 'to foster dignity' as 'a visible sign of the Christian community'. ⟶*Scott Jordan Harris*

(Photo © Jeffrey Murrell)

Directed by Tim Robbins
Scene description: A Saintly woman walking
Timecode for scene: 0:01:20 – 0:05:10

LOLITA (1997)

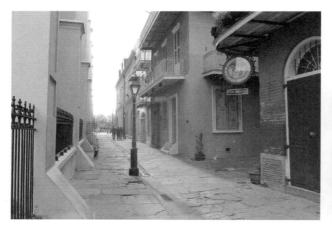

IN THE SECOND BIG SCREEN adaptation of Nabokov's classic novel, Jeremy Irons plays Professor Humbert Humbert while Dominique Swain plays Lolita, the underage step-daughter with whom he is having an affair. After a terrible row, caused by Humbert's intensifying jealousy, the girl runs screaming from their apartment. The professor follows, repeatedly apologising, but Lolita will not stop. She grabs her bicycle and cycles off into the rain, with Humbert traipsing weakly behind. The action is said to occur in New England but no-one who has ever visited (or even seen a photograph of) Pirate Alley in New Orleans is likely to mistake its true location. Pirate Alley, or Pirate's Alley as it is commonly known, sits between two New Orleans landmarks – the St. Louis Cathedral and the former Spanish governor's mansion, The Cabildo – and contains a third, the so-called Faulkner House, where William Faulkner wrote his first novel. What's more, the narrow alley is itself a storied landmark, which supposedly once hosted gatherings of pirates and supposedly still hosts gatherings of ghosts. Humbert is one of the most unreliable of unreliable narrators and so perhaps Adrian Lyne so clearly sets this scene in New Orleans, while asking us to believe it is set in New England, as a way of indicating that the events Humbert relates are not to be entirely believed. If so, he makes Pirate Alley an excellent example of a filming location that conveys as much about a movie's characters and story as the events played out within it. ⦿ ***Scott Jordan Harris***

(Photos © Gabriel Solomons)

Directed by Adrian Lyne
Scene description: Tears in the rain
Timecode for scene: 1.22.12 – 1.22.50

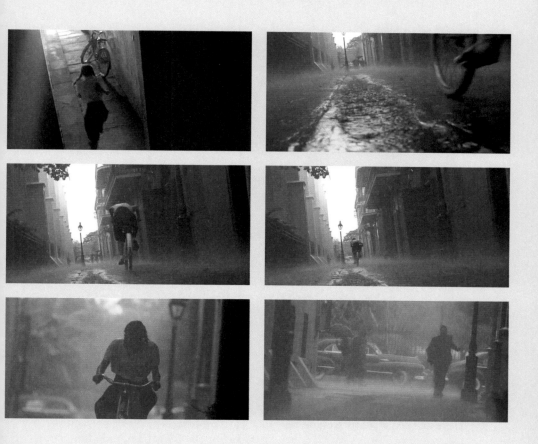

DOUBLE JEOPARDY (1999)

LOCATION

Hermman-Grima House exterior and courtyard, 820 Saint Louis Street, LA 70112

DOUBLE JEOPARDY DEPICTS female survival and triumph over staggering odds. In Seattle, Nick Parsons (Bruce Greenwood) fakes his death, framing his wife Libby (Ashley Judd), who is subsequently convicted. After serving prison time, Libby jumps parole, embarking upon a near-fatal quest to find her son. Libby discovers that Nick has reinvented himself as Jonathan Devereaux, prominent New Orleans resident and owner of the Maison Beau Coeur hotel in the French Quarter. Exterior shots of this scene were filmed at the Hermman-Grima House, a historic 1831 Federal mansion that is now a museum. Yet 'house of good heart' is a misnomer: the charming veneer of its proprietor belies his true nature as a con artist/murderer. Libby, literally dressed to kill in a glamorous Armani ball gown, infiltrates the Annual Bachelor's Auction, a black-tie charity affair in the Maison Beau Coeur/ Hermann-Grima's fabled courtyard, which here features chandeliers, ice sculptures, and Louisiana R & B legend Joe Simon's song 'If You're So Smart, How Come You Ain't Rich?' The evening's proceeds benefit the Antebellum Association; there a reference to the 'War of Northern Aggression' while Jonathan, boasting a Good Ole Boy drawl, masquerades as a charming, witty Southern Gentleman. With an astounding $10,000 bet, Libby 'wins' the auction, confronting Jonathan/Nick, but when she spots parole officer Travis Lehman (Tommy Lee Jones) among the partygoers, she surreptitiously slips away, her exit as swift as her arrival. This is Libby's first, but not final, showdown with Nick at the Maison Beau Coeur. **↝Marcelline Block**

(Photo © Gabriel Solomons)

Directed by Bruce Beresford
Scene description: Libby makes a winning bid
Timecode for scene: 1:07:54 – 1:15:36

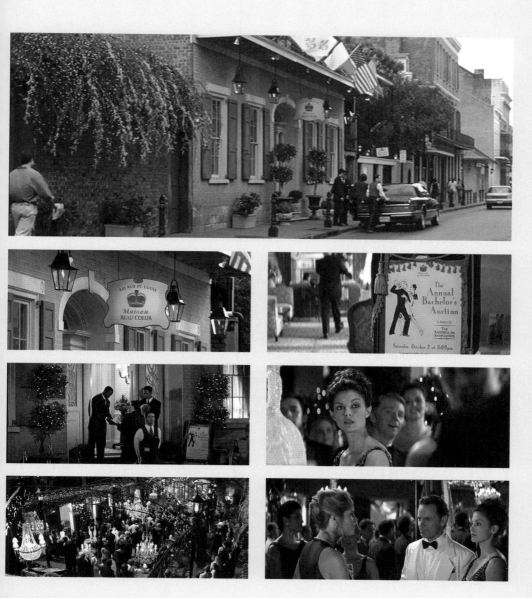

MONSTER'S BALL (2001)

Bud's Broiler, 500 City Park Avenue, LA 70119

MONSTER'S BALL IS SET near the notorious Louisiana State Penitentiary. This scene, however, occurs in the original Bud's Broiler, a New Orleans restaurant since 1952, famed for its charcoal cooking. Leticia (Oscar-winner Halle Berry), a waitress at Bud's, whose husband, Lawrence, was recently executed in the electric chair, rushes to make her shift. As she changes into her uniform, the manager announces she has already been replaced. The drab and gloomy shots of Bud's interior clash with the visitor's expectation of New Orleans (images of Mardi Gras, Bourbon Street, the French Quarter, etc). Far from the cosmopolitan and urban, *Monster's Ball*'s narrative is located in rural Louisiana, seething with prejudice, ignorance and racism, as exemplified by two Corrections Officers, Buck (Peter Boyle) and his son Hank (Billy Bob Thornton). This scene, at a crucial juncture of *Monster's Ball*, reflects a landscape of loss. Leticia's new widowhood is compounded by the loss of her job and the breakdown of her car, which forces her to arrive at Bud's by taxi. These events foreshadow impending, irreversible losses: following the death of her young son, she is evicted. But these losses bring together Leticia and Hank – a regular at the diner where Leticia works after Bud's fires her. Their romance blossoms although Hank aided in Lawrence's execution. Hank and Leticia mourn their children – Sonny (Heath Ledger), Hank's son – also a C.O. – was incapable of participating in Lawrence's execution and subsequently committed suicide. Finding happiness together, Hank and Leticia hide their personal connections to Lawrence. •➤*Marcelline Block*

(Photo © http://www.budsbroiler.com)

Directed by Marc Forster
Scene description: Leticia gets fired
Timecode for scene: 0:38:46 – 0:39:54

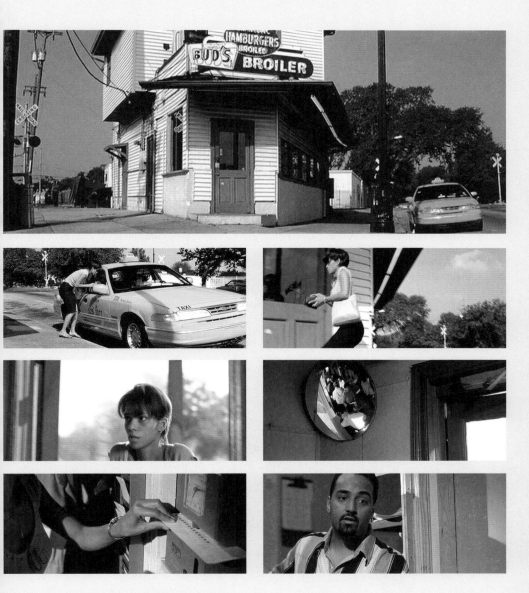

HOLLYWOOD SOUTH

Text by
SCOTT
JORDAN
HARRIS

CINEMA HAS DONE MUCH to help New Orleans recover from Hurricane Katrina. Films have documented Katrina's devastation; films have shown the efforts of New Orleans natives to ensure their city survives; and, as in Harry Shearer's *The Big Uneasy* (2010), films have howled with indignation at the US government's response to the disaster. But many of the movies that have done most to help New Orleans recover from Katrina make no mention of the flooding. They did not choose Hurricane Katrina as their subject, but they did choose New Orleans as their filming location – and, consequently, poured money into its economy. Post-Katrina, an increasing number of production crews have shot in The Big Easy – so many, in fact, that partly by right and partly by clever self-promotion, Louisiana has come to be called 'Hollywood South'.

The reason for the flurry of location shooting in NOLA is not, of course, the American film industry's desire to aid the city's catastrophe-stricken economy. It is the result of legislation passed three years before Katrina struck: 2002's Louisiana Motion Picture Incentive Act. The act is complex and all but impenetrable to the lay person, but it can essentially be broken down into two parts: the Investor Tax Credit and the Labor Tax Credit. The first gives a 30 per cent tax credit on film production costs, while the second gives a 5 per cent tax credit on wages paid to Louisiana residents during film production. Films, music videos, and television programmes are all eligible for the credits – but their makers must spend over $300,000 in the state to qualify. The Incentive Act was designed to bring big-scale, big-spending film productions to Louisiana – and it worked magnificently. As *Fast Company* magazine's Anya Kamenetz wrote in her 2007 article 'The Short, Shady History of Hollywood South':

'I had come home to New Orleans [...] to report on a piece of good news: Louisiana had just become the No. 3 film-producing state in the nation, behind only California and New York. Direct spending on film, TV, and music-video production rose from $12 million in 2002 to more than $1 billion projected for 2007. [...] Even Katrina didn't halt a single production.'

This increase continued beyond 2007. The Motion Picture Association of America records that, in 2009, '47 movies and 15 TV series [were] filmed in Louisiana' while the following year, '69 movies and 18 TV series' were shot in the state. The most significant statistic the MPAA reports, however, does not detail how many films are made in Louisiana, but how much money is spent, and how many people are employed, in making them. It notes that, at time of writing, 'the motion picture and

television industry is responsible for 7,632 direct jobs and $308.7 million in wages in Louisiana'. Many of those jobs are created – and much of that money is spent – in New Orleans, which dominates film production in the state. Baton Rouge may be the capital of Louisiana, but New Orleans is the capital of Hollywood South.

New Orleans's unique nature and unmistakable scenery has always exerted a pull on film-makers whose stories involve the city. No film using soundstage sets instead of location shooting has ever quite replicated The Big Easy's atmosphere (though some have made excellent attempts) and so New Orleans is never likely to lose its appeal as a filming location for movies that are actually set there (many films are, of course, not shot in the cities in which they are set).

It is interesting to note, though, that New Orleans now appears to be an attractive shooting location for films that need not be set there. The endless action sequences of *12 Rounds* (Renny Harlin,

> **New Orleans's unique nature and unmistakable scenery has always exerted a pull on film-makers whose stories involve the city. No film using soundstage sets instead of location shooting has ever quite replicated The Big Easy's atmosphere...**

2009), for example, could be shot in any other major American city and one wonders if they would have been had not filming conditions in New Orleans been so agreeable. Furthermore, while New Orleans had not previously been renowned as a shooting location capable of doubling as other locations, recent films have made use of NOLA sites for scenes that are categorically not set in the city.

In the comic-book-inspired western *Jonah Hex* (Jimmy Hayward, 2010), for instance, the New Orleans City Park becomes unrecognisable as it is turned into the fictional town of 'Cactus Hole', while in *The Mechanic* (Simon West, 2011) the New Orleans World Trade Center doubles for a building in Chicago. If Louisiana's film-making boom continues, filmgoers are likely to see not only more films that explicitly feature New Orleans but also more films that feature the city standing in for other locations.

But Louisiana's film-making boom may not continue. As Dr Robert Tannenwald, former president of America's National Tax Association, wrote in a December 2010 article entitled 'State Film Subsidies: Not Much Bang for Too Many Bucks':

'State film subsidies are costly to states and generous to movie producers. Today, 43 states offer them, compared to only a handful in 2002.'

With state film subsidies like Louisiana's now commonplace and competitive, and the bills for them falling to taxpayers, it is uncertain that Louisiana will be able to sustain the expansion of its film industry a©nd retain its reputation as Hollywood South. With state subsidies cancelling each other out, Louisiana will surely find it increasingly difficult to retain its position among America's most filmed-in states, never mind mount a serious challenge to the supremacy of California and New York. Were Louisiana to make its subsidies even more appealing to film-makers, it would mean the state itself earning less money per production and, were other states to do the same, a disastrous 'race to the bottom' could occur. In fact, Tannenwald believes one is already occurring.

This is a golden age for New Orleans film-making – but that golden age may already be ending. ✤

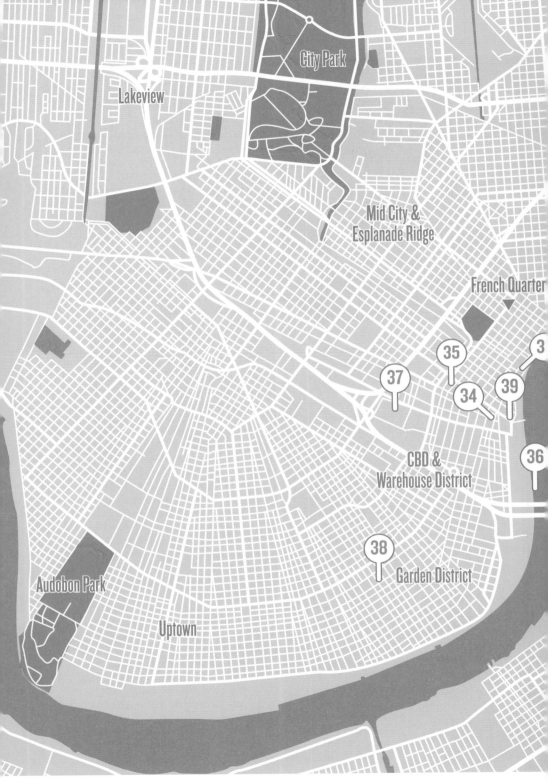

City Park

Lakeview

Mid City &
Esplanade Ridge

French Quarter

35

3

37

39

34

36

CBD &
Warehouse District

38

Garden District

Audobon Park

Uptown

NEW ORLEANS LOCATIONS

SCENES 33-39

RUNAWAY JURY (2003)

Café du Monde, French Market, 800 Decatur Street, LA 70116

WITHIN THE ICONIC Café du Monde, Marlee (Rachel Weisz) attempts to extort $10 million from attorney Wendell Rohr (Dustin Hoffman) to guarantee a jury vote in his favour against the powerful gun company on trial. However, Rohr believes in the integrity of the legal system. This scene's location is brimming with New Orleans, and specifically French Quarter, clichés: a saxophonist playing the city's unofficial hymn 'When the Saints Go Marching In'; tourists enjoying Acadian cuisine (chicory-inflused café au lait and beignets a visible trace of which can be seen in a powdered-sugar mustache on Rohr's face), while on the cafe's porch Marlee and Rohr are engrossed in matters of justice. The gravity of Marlee and Rohr's discussion contrasts with the pleasant atmosphere of the Café du Monde. Although their conversation begins amicably, it soon degenerates into hostility, climaxing in physical aggression as Rohr grabs Marlee, demanding an explanation of her background and motivation for manipulating the trial. Rohr's Southern Gentleman veneer cracks as he shows his rough disposition: Rohr and Marlee both hide who they really are. Beneath Rohr's meticulously selected shabby wardrobe – through which he masquerades as one of the 'people' – lies a powerful force. Rohr's expression of violence in the vibrant Café du Monde suggests The Big Easy has an undercurrent of danger that can come to the surface at any moment, like in the film's frenzied opening sequence when an armed gunman on a rampage shoots his co-workers inside a pristine, historic, New Orleans building. **•›Marcelline Block**

(Photos © Gabriel Solomons)

Directed by Gary Fleder
Scene description: 'who hurt you? What made you this way?'
Timecode for scene: 1:21:13 – 1:24:34

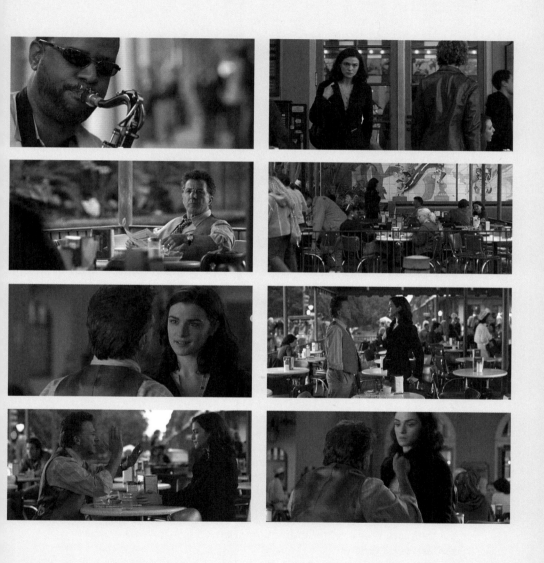

A LOVE SONG FOR BOBBY LONG (2004)

Rock Bottom Lounge, 301 Tchoupitoulas Street, LA 70115

WHEN BOBBY LONG (John Travolta) and Lawson Pines (Gabriel Macht) first stumble into the Rock Bottom Lounge, viewers might roll their eyes. Two failures drinking their lives away under that sign? What an affectation by the screenwriter! But the Rock Bottom Lounge is a real place in New Orleans and, while its name may make for an obvious joke, its role within the film reflects its real life. It is a gathering place for the 12th Ward, and serves as the home of the Prince of Wales social club, which has organized parades and cook-outs for 80 years. There are no parades in *Bobby Long*, but there is community. It's the kind of dive bar you'll find in any city, but which seems especially evocative in New Orleans. The red walls are a dim relief from the sticky heat, and contain years of cigarette smoke and alcohol residue. You can always get a steaming bowl of red beans and rice or a pile of angry crawfish, and there's almost always live music. And booze – lots and lots of booze, the lifeblood of New Orleans. Rock Bottom is where *Bobby Long*'s 'invisible people' go. It's where the uneasy trio of Bobby, Lawson and Pursey (Scarlett Johansson) bear their souls, quote literature, and tear up their relationships over beer and cigarettes. Here is where Pursey begins to discover her origins and plot her future. Their lines are scripted, of course, but the place is so grimly authentic you can forgive its clumsy poetry.
⤳Elisabeth Rappe

(Photo © Infrogmation of New Orleans)

Directed by Shainee Gabel
Scene description: Hitting rock bottom
Timecode for scene: Location recurs throughout film

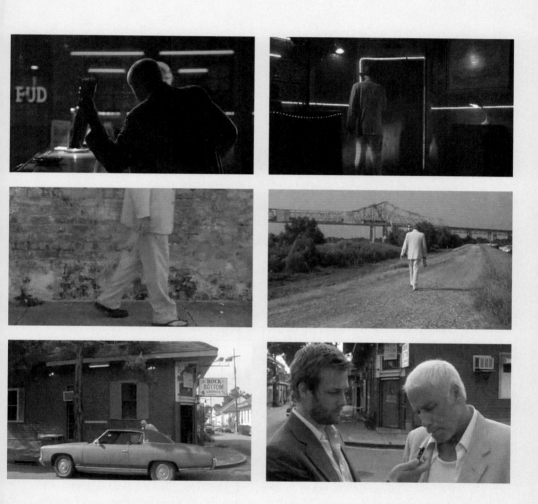

RAY *(2004)*

LOCATION *The Orpheum Theatre, 129 University Place, LA 70112*

THE ECSTATIC HIGHS and excruciating lows in the life of Ray Charles were memorably brought to the big screen in Taylor Hackford's 2004 biopic. Featuring an Oscar-winning performance from Jamie Foxx as the lead, *Ray* focuses on the 30-year period in Charles's career from his early days as a struggling musician to the height of his global popularity, taking in his womanising ways, experiments with musical styles, heroin addiction, and stand against racial segregation. Hackford's independent production, funded by American entrepreneur Philip Anschutz, was largely shot, but not set, in Louisiana and New Orleans, with the locations used standing in for many of the places named. In *Ray*'s most electrifying sequence, which comes after Charles's refusal to play before a segregated audience, he and his band are shown in full swing belting out 'Unchain My Heart' to a desegregated crowd during a concert in Indianapolis. As the crowd react wildly to the supercharged performance, the stage is invaded by audience members of all colours in a joyous rebuke of racial discrimination. Filming for this sequence took place in New Orleans's Orpheum Theatre in the city's Central Business District. Built in 1918, this 1,800-seater venue, a prime example of a 'vertical hall' designed to maximise sight lines and acoustics, has over the years opened its doors to vaudeville performers, operated as a cinema, and been the home of the Louisiana Philharmonic Orchestra. Severely damaged by floodwaters during Hurricane Katrina, the Orpheum has since been sold to a Dallas businessman for restoration. **Neil Mitchell**

(Photo © Karen Apricot)

Directed by Taylor Hackford
Scene description: A desegregated dance
Timecode for scene: 1:49:06 – 1:50:17

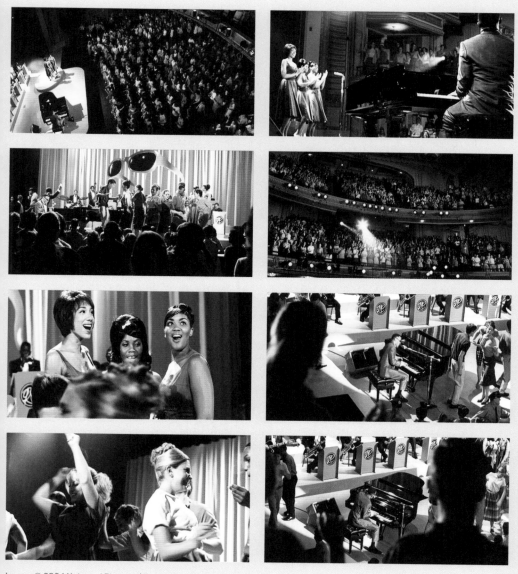

DÉJÀ VU (2006)

LOCATION *Alvin T. Stumpf Ferry on the Mississippi River*

WHEN PRODUCER JERRY BRUCKHEIMER, director Tony Scott, and their entourage roll into town you know that blockbuster action will follow. Scott, director of many a bombastic film, including *Top Gun* (1986) and *Enemy of the State* (1998), brought to New Orleans film-making on a scale not seen before in the city. His typically high-concept, science fiction-tinged thriller *Déjà Vu* throws Denzel Washington's ATF Special Agent Doug Carlin into a world of domestic terrorism and covert FBI technology in a bid to track down the bombers responsible for the mass murder of hundreds of Fat Tuesday party-goers aboard the Alvin T. Stumpf Ferry. The ferry, named after a former Louisiana state senator, carries passengers at regular intervals across the Mississippi from Canal Street in the Central Business District to Algiers on the West Bank, and is hugely popular with residents and tourists alike. In *Déjà Vu*'s technically dazzling opening sequence, the Alvin T. Stumpf is shown packed with Mardi Gras revellers, many of them US Navy servicemen and women, before it is blown to high heaven under the shadow of the Crescent City Connection Bridge. Scott and his crew spent a month preparing the sequence, re-enforcing the Alvin T. Stumpf's decks with sheet metal before laying down explosive charges. Through a combination of pyrotechnics and digital wizardry the ferry was reduced to a burning deathtrap onscreen. In reality, it was only out of action for two weeks and, once restored, resumed normal service. **↝Neil Mitchell**

(Photos © Gabriel Solomons)

Directed by Tony Scott
Scene description: The bombing of the Alvin T. Stumpf ferry
Timecode for scene: 0:00:00 – 0:05:41

Images © 2006 Touchstone Pictures / Jerry Bruckheimer Films / Scott Free Productions

WHEN THE LEVEES BROKE:
A REQUIEM IN FOUR ACTS (2006)

New Orleans Superdome, 500 Poydras Street, LA 70112

THE NEW ORLEANS SUPERDOME is so much more than a location for a film. It is more, even, than a sports venue. What it really is is a shelter, one of the designated 'shelters of last resort' during Hurricane Katrina in 2005. It housed tens of thousands of people from the raging winds and waters, when they no longer had houses of their own. And it was battered in the process, revealing the city's agony in microcosm. We see this in the first episode of Spike Lee's 'four act' documentary about Katrina, *When the Levees Broke*. Early in that episode, footage from inside the dome shows part of its roof being prised open by the winds, letting the rain come cascading in. But it gets worse. Later, interviewees tell us about the conditions in the dome at the time: the sewage flowing back from the toilets; the sticky heat as more and more people are crammed under its roof; the confusion and fear. Around one hundred people are reported to have died in the dome during those days, many of them due to heat exhaustion. But the dome stayed standing – and so, in spirit, did its temporary occupants. One of the most moving sequences in Lee's documentary shows the dome's refugees, amid it all, singing the gospel song 'This Little Light of Mine'. A year later, the Superdome would host its first football match since Katrina. And the result? A victory for the New Orleans Saints. ◄►***Peter Hoskin***

(Photo © Gabriel Solomons)

Directed by Spike Lee
Scene description: *This little light of mine*
Timecode for scene: *Act one, 1:01:50 – 1:04:49*

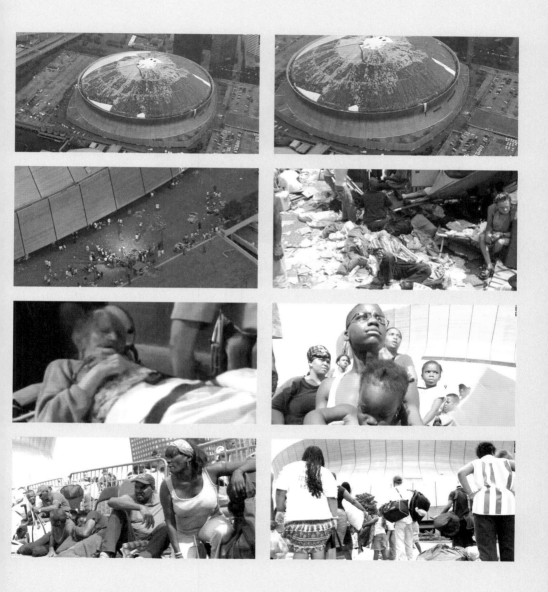

Images © 2006 40 Acres & A Mule Filmworks

THE CURIOUS CASE OF BENJAMIN BUTTON (2008)

LOCATION *The Nolan House, 2707 Coliseum Street, LA 70130*

'IT'S A FUNNY THING ABOUT COMIN' HOME. Looks the same, smells the same, feels the same. You'll realize what's changed is you.' So muses the titular Benjamin Button, a man condemned to age in reverse, and pass people, places, and events at the wrong time. The slip of time and the constant of change means there are two things that remain steady in his life: his love for the ethereal Daisy (Cate Blanchett) and his residency in a nursing home run firmly by his adoptive mother, Queenie (Taraji P. Henson). A home for the aged is the perfect haven for an ancient infant, but even as Benjamin becomes younger, he always circles back to this refuge. The symbolism is achingly obvious. Queenie's house stands solidly, waiting for its curious son to return, its walls no sadder or wiser than the last time he left. He may be forced to consummate his love 'in the middle' of life, and pursue recklessness at the end, but he never has to wait or catch up to his home. And where else could this home be but in New Orleans, a city that seems to exist outside of time, poised perfectly between decay and stability? The Nolan House also stands as a bland contrast to the lush colours and spectacular vistas David Fincher splashes across his film. It's a comforting break for our eyes, allowing us to slow down, appreciate the past, and await the future's string of exotic sights alongside Benjamin. ⁕**Elisabeth Rappe**

Directed by David Fincher
Scene description: There is a house in New Orleans
Timecode for scene: Locations recur throughout the film

BAD LIEUTENANT: PORT OF CALL NEW ORLEANS (2009)

LOCATION *Audubon Aquarium of the Americas, 1 Canal Street, LA 70130*

HANG ON, WHERE DID THIS COME FROM? After almost two hours of movement, heat, frazzle and reptilian menace, *Bad Lieutenant: Port of Call New Orleans* finishes with a shot so calm and soothing that it actually comes as a shock. The titular character, played throughout with chemical intensity by Nicolas Cage, is sitting with a reformed convict on the floor of the Audubon Aquarium of the Americas, their backs to one of the great, huge tanks there. Everything is blue, and fish glide across the background as the two men chat with each other. And all you can think is 'Where did this come from?' But then you consider it for a minute longer and make the connection. The film is ending as it started – with water. Its opening had Cage rescue this same convict from the rising flood waters that followed Hurricane Katrina, wrenching his spine in the process. This ending suggests that the city has done much to heal itself in the meantime, but can the same be said of Cage's mad, inverted cop? The answer to that is as uncertain as the answer to his final, strung-out inquiry, 'Do fish have dreams?' There are, after all, sharks in the tank behind his head. The predators persist. **➤Peter Hoskin**

(Photo © Gabriel Solomons)

Directed by Werner Herzog
Scene description: Do fish have dreams?
Timecode for scene: 1.51.50 – 1.52.40

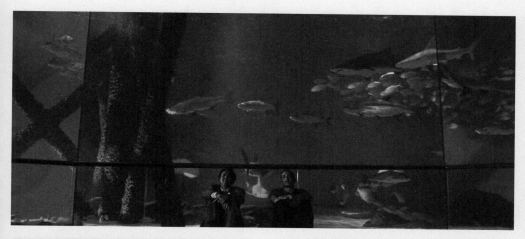

AFTER THE LEVEES BROKE

Text by
PETER
HOSKIN

Hurricane Katrina Onscreen

IT BEGAN SOMEWHERE around the Bahamas, the result of one minor meteorological phenomenon meeting another. And it grew into a raging swirl of wind, rain and electricity that tore through the American Southeast in a week. This was the hurricane they called 'Katrina', and it is now near-synonymous with New Orleans. When Katrina hit the city in late August 2005, they were expecting widespread destruction, but what they got was something worse. The 'Hurricane Protection System' that to protected New Orleans from the waters of the Mississippi and Lake Pontchartrain couldn't withstand the storm. It collapsed, and the city was flooded with billions of gallons of water, dirt and detritus.

How can cinema respond to such awful devastation? The answer that many film-makers have since reached is to simply show it as it was. This is the impulse behind the numerous

documentaries that have focused on Katrina and its aftermath, including the most famous: Spike Lee's four-part television film *When the Levees Broke* (2006). Lee – more often a director of feature films, of course – layered firsthand testimony atop more first-hand testimony to produce a collage of news reports, photographs, handheld footage and interviews. The result is something far more affecting than could be contrived on a studio back lot. There is, after all, no more revealing footage of Katrina and its effects than footage of Katrina and its effects. There are no more revealing words than those spoken by Katrina's real-life victims.

What Lee's film does, more than anything else, is capture the amazing (and frequently strange) vibrancy of New Orleans. I've written elsewhere in this book about one of the film's most uplifting sequences, in which a group of tired, distressed and displaced folk start whooping up praise to God and singing 'This Little Light of Mine'. And there's something similar in a later episode. A funeral procession winds through the rubble-strewn streets of the city, a black carriage and coffin trailing behind it. Except this isn't a normal funeral procession – the carriage has 'Katrina', written on its side. By the time the jazz horns kick in, and the mourners start to dance, you know that this is part lament, part celebration. They've come to bury a disaster.

But a disaster can never be completely buried, as another documentary, Harry Shearer's *The Big Uneasy* (2010), makes clear. Released five years after Katrina, this film asks insistently – what went wrong? Why couldn't New Orleans's flood protection system

stand up to the onslaught of a hurricane? And its unsettling conclusion is that a mixture of bureaucratic incompetence and deceit was to blame. In this, the film is representative of another strand to Katrina's cinematic afterlife: rage against the state machine.

In *Trouble the Water* (Carl Deal and Tia Lessin, 2008), based around handheld footage shot on the scene by an aspiring rapper, this rage comes burning through. As a black Tennessean woman puts it to the camera, 'My son wanted to join the army – but you're not going to fight for a country that does not give a damn for you.'

There is even a documentary feel to some of the fictionalized Katrina films – or, rather, television shows. David Simon's *Treme* (2010, ongoing) is a New Orleanian counterpart to his earlier *The Wire* (2002–08): an analysis of race, class, politics, society and people, all set in the quietly tumultuous months and years after the hurricane. Hundreds of the city's residents have appeared in the show so far, lending an authenticity to its drama. And its storylines are almost as low-key as everyday life. But this is everyday life in New Orleans that we're talking about, so it's invigorating all the way.

How can cinema respond to such awful devastation? The answer that many film-makers have since reached is to simply show it as it was.

When it comes to feature films, Katrina has generally remained in the background: more a plot point than the whole point. David Fincher's New Orleans-set tale of a man ageing backwards, *The Curious Case of Benjamin Button* (2008), ends with the hurricane approaching – a comment, perhaps, on the city's own lifecycle of damage and repair. And Werner Herzog's *Bad Lieutenant: Port of Call New Orleans* (2009) begins with a prisoner being rescued from the rising flood waters. How much we ought to read into the film's final shot, of an azure blue tank in an aquarium, I'm not sure. It could mean everything or nothing. Herzog leaves it up to you.

One Katrina film that certainly doesn't leave it up to the viewer is *Hurricane Season* (Tim Story, 2009). It takes a monumental true story – of a high school basketball coach who rebuilt his team from the ruins – and reduces it into a fairly pedestrian sports movie. Far better, for giving a sense of New Orleans now, is the documentary that Spike Lee filmed four years after *When the Levees Broke*, called *If God is Willing and Da Creek Don't Rise* (2010). That offers the power of reality once again. Good things happen, like homes being rebuilt. Bad things happen, like the BP oil spill of that year. Recovering from the physical and psychic shock of Katrina was always going to be difficult, but New Orleans abides. That is a triumph in itself. ✤

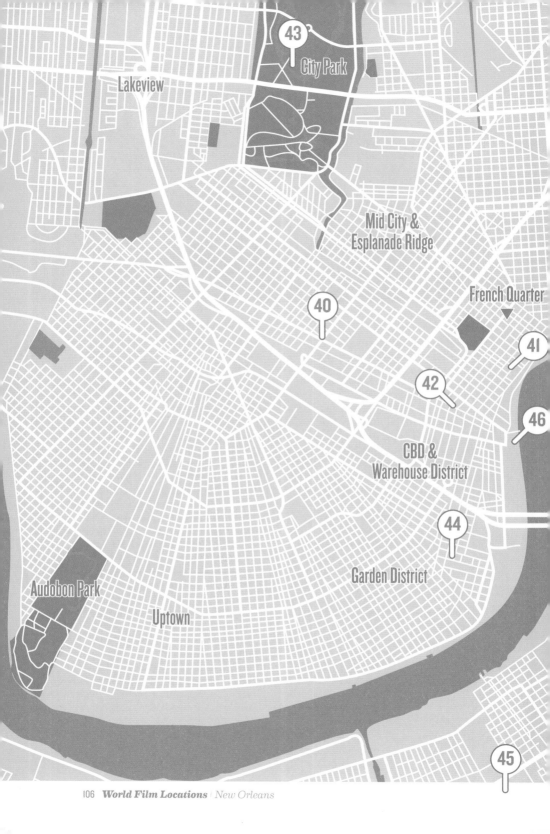

Lakeview

43 City Park

Mid City &
Esplanade Ridge

French Quarter

40

41

42

46

CBD &
Warehouse District

44

Garden District

Audobon Park

Uptown

45

NEW ORLEANS LOCATIONS

SCENES 40-46

I LOVE YOU PHILLIP MORRIS (2009)

LOCATION *Orleans Parish Criminal District Court, 2700 Tulane Avenue, LA 70119*

THE NEIGHBOURHOOD OF Tulane and Broad in New Orleans is strongly associated with the values of law and order, as it holds a justice complex comprised of the Orleans Parish Criminal District Court, Traffic Court and Parish Prison. Located on Tulane Avenue, the Criminal District Court was erected in 1929 and the trial, depicted in *JFK* (Oliver Stone, 1991), of local businessman Clay Shaw for conspiracy to assassinate President John F. Kennedy was held there in 1969. The case being tried there in the based-on-fact comedy *I Love You Phillip Morris* is of less political significance, but of interest because the defence attorney is actually an enterprising con artist whose entire legal knowledge was acquired in a prison law library. Doubling for a courthouse in Houston, Texas, where the real-life events being shown occurred, the time-honoured traditions implied by the imposing location interior are mocked by the grandstanding of Steven Jay Russell (Jim Carrey). Using fake credentials, the master impersonator defends Eudora, a former neighbour of his gay lover, against the charge of failing to pay fees to a building contractor. Dressed in appropriate attire for an eccentric legal practitioner – complete with bow tie and thick-rimmed glasses – Russell tests the patience of the court with inapplicable arguments and exaggerated mannerisms before bluffing that his briefcase contains vital evidence when it actually holds only his lunch and a photograph of his boyfriend. Realising he is losing the case in open court, Russell requests to be seen in chambers, setting the stage for victory. **➻John Berra**

(Photo © Kate Drabinski)

Directed by Glenn Ficarra and John Requa
Scene description: *A con artist shows off his litigation skills*
Timecode for scene: *0:40:28 – 0:42:04*

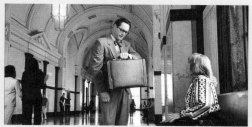

Images © 2009 Europa Corp. / Mad Chance

THE PRINCESS AND THE FROG (2009)

LOCATION *(An animated version of)* St Louis Cathedral, 615 Pere Antoine Aly, LA 70116

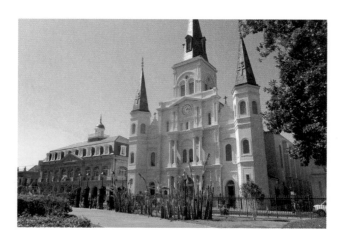

PERHAPS CINEMA'S most visually flattering evocation of New Orleans comes not from beautiful cinematography but from beautiful animation, in Disney's *The Princess and the Frog*. The film is an unashamed celebration of New Orleans and it is fitting, therefore, that its climax occurs at what is probably the city's best-known building: the St Louis Cathedral. Charlotte, the wealthy 'Princess of the Mardi Gras', runs to the cathedral for her wedding to the dashing Prince Naveen but is aghast to discover an impostor who has helped turn Naveen into a frog. When the real prince arrives, in frog form, Charlotte prepares to kiss him before midnight, to turn him human again, so they can be married. But when she sees the love that has developed between the prince and her best friend, Tiana, while Tiana and Naveem have been forced to live as frogs, Charlotte decides to turn them human so they can be together instead. Unfortunately, though, midnight has passed and the expected happy ending is prevented – or at least postponed. In contrast to the fanciful nonsense of the scene's events, its backdrop is astonishingly realistic. John Lasseter, Disney's chief creative officer, told Mike Scott of the *New Orleans Times-Picayune* that his motto during production was 'get the details right'. And his team certainly got the details right: their version of the St Louis Cathedral is remarkably accurate and a sterling example of how first-class location shooting can take place in an animator's studio miles from the location in question.
⇝ Scott Jordan Harris

(Photo © Gabriel Solomons)

Directed by Ron Clements and John Musker
Scene description: Kissing a frog on the cathedral steps
Timecode for scene: 1:14:43 – 1:16:47

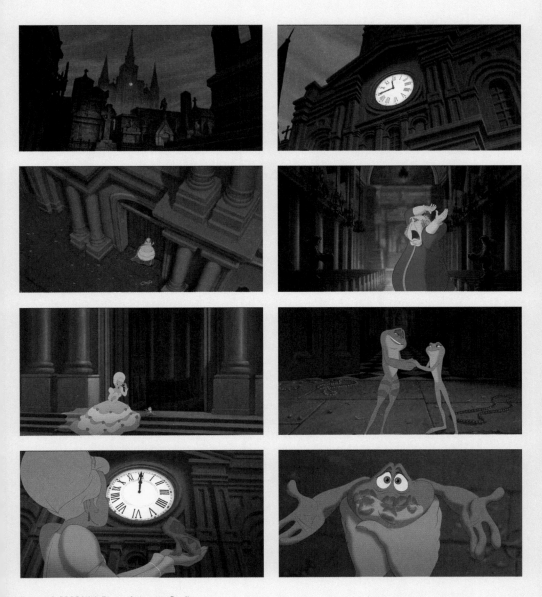

12 ROUNDS (2009)

The Maritime Building, 203 Carondelet Street, uptown lake corner with Common Street, Central Business District, LA 70112

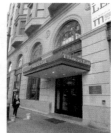

WHEN DETECTIVE DANNY FISHER'S girlfriend is abducted by a dastardly terrorist, the policeman, played by professional wrestling superstar John Cena, must complete a series of devilish tasks to earn her release. Told there is a fire at 'The Orleans Saving and Loan', he races there with his fireman brother, breaks in and finds a bomb on the tenth floor. A phone call from the terrorist informs him that he has 'seven minutes to cross the 23 city blocks between here and the Nicholls Street Wharf' or the bomb will detonate. 'Seven minutes? We won't even be out of the building in seven minutes!' says Danny's brother. 'That's if we take the stairs!' says Danny, tossing a roll of cable through the window and inventing extreme abseiling. It's a typical American action movie moment in a film filled with typical American action movie moments, and it takes place at a New Orleans institution. But that institution is not, in reality, 'The Orleans Saving and Loan': it is The Maritime Building, the city's oldest skyscraper. Built in 1893 by Thomas Mally, The Maritime has, across three centuries and three names, always been one of the most notable buildings in New Orleans, and it is interesting that *12 Rounds* chooses to use its famous exterior but not its famous identity. Perhaps this is because of the redevelopment the building underwent between 2006 and 2010: it now hosts luxury apartments, a rooftop fitness centre, a sundeck and a pool. Abseiling facilities are, though, as yet unavailable. ➻ *Scott Jordan Harris*

(Photos © Gabriel Solomons)

Directed by Renny Harlin
Scene description: Fire at the savings and loan
Timecode for scene: 0:36:34 – 0:45:00

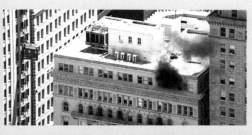 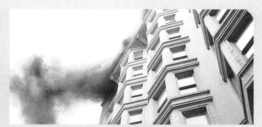

 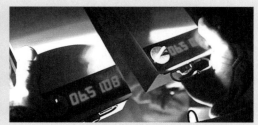

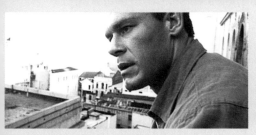 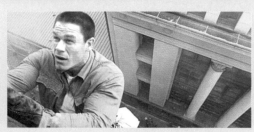

JONAH HEX (2010)

LOCATION *New Orleans City Park, LA 70124*

JONAH HEX IS A scarred bounty hunter who roams the wilds of America. It is said he has only two companions: death and the acrid smell of gun smoke. But, in 2009, Hex had another vital companion: a tax credit under the 2002 Louisiana Motion Picture Incentive Act. When Warner Brothers decided to give the mangled gunfighter a film, they didn't do the obvious and shoot in a western locale, such as New Mexico, but instead took the angry Confederate back to his home turf. While the film is an unmitigated disaster, the locale lends it a delicious swampy atmosphere that would have been hard to achieve anywhere else. No scene better illustrates the flexibility of New Orleans as a budget-friendly location than the one in which Jonah (Josh Brolin) moseys into a town called Cactus Hole. New Orleans City Park is transformed from a distinctly Southern spread of palms and cypress into the adobe and arches of Old Mexico. The only evidence that we're still down in New Orleans is the greasy sheen that coats everyone's faces: an unavoidable side-effect of filming in the unforgiving climate, but one that gives Cactus Hole an unwashed authenticity. The town may not be authentic to Mexico, but it has an outlandish quality that suits Hex's comic book origins. It's the perfect place for Jonah to gulp some whiskey, shoot a mocking stranger, and bed a whore before departing. Cactus Hole is a fantastically detailed location that exists only for a few blinks of celluloid. ⤳ **Elisabeth Rappe**

(Photo © Ioba Standard)

Directed by Jimmy Hayward
Scene description: Jonah Hex rides into cactus hole
Timecode for scene: 0:17:30 – 0:23:03

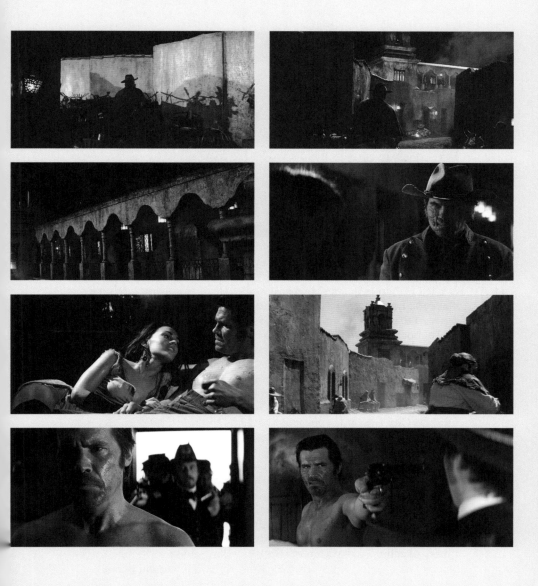

RED (2010)

LOCATION *St Vincent's Guest House, 1507 Magazine Street, LA 70130*

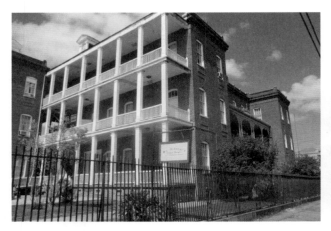

'**I NEVER THOUGHT** this would happen to me. Vietnam, Afghanistan... Green Springs Rest Home.' With its comfortable communal area and helpful staff, this particular retirement home is probably not the worst place to wind down after a hectic career. However, former government operative Joe Matheson (Morgan Freeman) is not your average resident, having served his country in countless international conflicts and covert missions. Sadly, advancing years and stage-four liver cancer have resulted in an unremarkable later life at Green Springs Rest Home, where Joe resorts to harmless innuendo in order to amuse himself, getting away with his immature behaviour because of his easy-going charm. As Joe settles in front of the television, it seems to be a day much like any other until he receives an unexpected visit from his similarly retired colleague Frank Moses (Bruce Willis). After exchanging some friendly banter, Frank informs Joe that he has been brought back into the thick of the action after surviving an attack at his suburban home by a heavily armed wet team. Although they are now cashing pension checks, Frank and Joe still have sufficient skills for their top secret files to be labelled Red (Retired Extremely Dangerous). Joe remains well-connected enough to find out that the attack on Frank was carried out by an independent South African hit team which is also suspected of killing a reporter for *The New York Times*. Frank advises Joe to watch his back, but Joe laughs, rationalising that, at 80 years of age, he has relatively little to worry about. ⦿*John Berra*

(Photos © Gabriel Solomons)

Directed by Robert Schwentke
Scene description: Retired teammates reunite at Green Springs Rest Home
Timecode for scene: 0:17:22–0:20:31

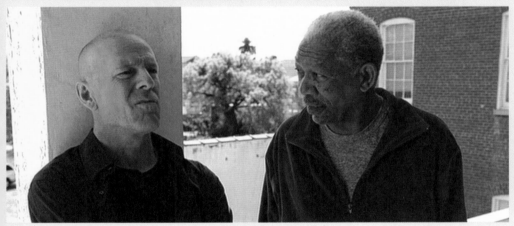

THE BIG UNEASY (2010)

MANY SCIENTISTS AND ENGINEERS speak knowledgeably in *The Big Uneasy*, Harry Shearer's shocking investigation into the true reasons for the devastation caused by Hurricane Katrina. None, though, is quite as persuasive as Tad Benoit, a handsome, smiling musician without academic expertise but with a lifetime of passion for the Wetlands. He is 'sitting right in the middle of a swamp' and looks as at home there as any of the interviewees who are filmed in their offices or houses. He explains his point perfectly: 'When a hurricane hits a cyprus swamp, it's like a sponge: it just sucks it right up... There's no better protection from storms than this... All this was built by the Mississippi... and it's supposed to continue to build.' But it isn't continuing to build. Sherwood Gagliano, president of Coastal Environments Incorporated, informs us he has discovered 'the coast [is] no longer building... In fact, since about the 1930s, it [has] started retreating'. Levees constructed along the river prevent flow into its tributaries; saltwater has encroached; and soon we see the result. A still expanse of water, an occasional dead tree breaking its surface, reflects a yellowing sky. It's a picturesque scene, but a terrifying one: this was, and should be, a cypress swamp. The Wetlands are not, of course, within the New Orleans city limits, but this scene shows they are as much a part of the city as the French Quarter and the St Louis Cathedral. Without the Wetlands, New Orleans is naked. **◆Scott Jordan Harris**

(Photo © Dr. Tom Hoban)

Directed by Harry Shearer
Scene description: 'All this was built by the Mississippi'
Timecode for scene: 0:32:28 – 0:35:17

TAB BENOIT
Musician, Founder of Voice of The Wetlands

THE MECHANIC (2011)

LOCATION *World Trade Centre, 365 Canal Street, LA 70130*

THE TOWERING WORLD TRADE CENTRE of New Orleans is a 33-story skyscraper that was once the tallest structure in the city and the home of numerous foreign consulates. However, with demand for space decreasing and tax incentives being offered to film-makers following Hurricane Katrina, the building found itself doubling for a Chicago hotel in a typically violent star vehicle for action man Jason Statham. In this remake of the 1972 Charles Bronson thriller, soundstage interiors are matched with rooftop exteriors as cool-headed hit man Arthur Bishop (Statham) and his hot-tempered apprentice Steve McKenna (Ben Foster) struggle to escape after eliminating the leader of a cult-like church. Seemingly cornered by security personnel, the two assassins narrowly avoid bullets and exchange body blows with their pursuers, while a wide-angled shot of Bishop throwing a bodyguard over the edge not only shows the commercial design of the central business district but also echoes the existential atmosphere of the original film. With their options limited, Bishop and McKenna rappel down the side of the building, crashing through a lower floor window, and then split up to make separate exits amid the chaos caused by their out of control assignment. Aside from such spectacular concessions to the modern audience for action movies, this update of The Mechanic largely succeeds by casting the right star in the title role. Sadly, the current economic climate means that the World Trade Centre of New Orleans – whose owners proposed demolition in 2010 – will not be so easily rejuvenated. **John Berra**

(Photo © Gabriel Solomons)

Directed by Simon West
Scene description: An escape across a chicago rooftop
Timecode for scene: 0:53:44 – 1:03:00

PLEASURE PALACES

Text by PAMELA C. SCORZIN

A Brief History of New Orleans's Historic Cinemas

THE LONG AND FASCINATING relationship between New Orleans and film goes back to the beginnings of the US motion picture industry, at the start of the twentieth century. This unique American city, with its famous cross-cultural festivals and colourful annual celebrations, has proved irresistible to film-makers. Renowned as the birthplace of jazz, New Orleans has, of course, long been celebrated for its fascinating music. It is also renowned, and celebrated, for its distinctive Creole architecture. But what is perhaps less well-known internationally is that the greater New Orleans metropolitan area has also long been home to noteworthy cinema architecture, particularly in its small neighbourhood movie theatres. Years ago it was said that, no matter where you lived in town, a movie theatre was near. People in New Orleans walked, not drove, to the movies.

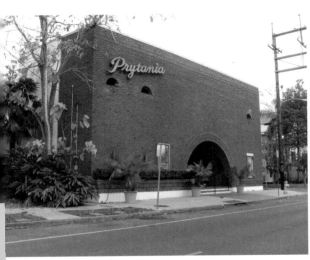

It is believed the city had the first continuously operating movie house in the United States: a Vitascope Hall, which opened at 623 Canal Street in 1896, and it was in 1914 that the cinema-building boom started in New Orleans. Many of the early film theatres built during this period were family-operated businesses and became a great part of community, as well as cultural, life.

In the 1920s, grand movie houses were constructed all across the United States, marking the beginning of the Golden Age of American movie palaces. Furthermore, nickelodeons were remodelled or replaced by larger, more luxurious motion picture theatres. Thus, the movie theatres of New Orleans, though distinct, were part of a national phenonenon that later saw the development from pretentious and highly elaborate movie palaces into cosy and comfortable neighbourhood cinemas.

Unfortunately, over the last several years, New Orleans has seen many of its significant movie theatres close. But it has not been natural disasters, like Hurricane Katrina, that have brought about the fall of New Orleans's famous little movie theatres and its long tradition of film exhibition. Rather, it has been social changes and new technologies, particularly changes to the commercial distribution of films and the recent construction of mega multiplex cinemas. Even so, some of NOLA's original movie theatres have survived and, helped by their rarity, have become tourists' attractions. Some, like the Prytania Theatre (located at 5339 Prytania Street, New Orleans, LA 70115) have even become true Louisiana landmarks. Today, the Prytania Theatre, built in 1915, is

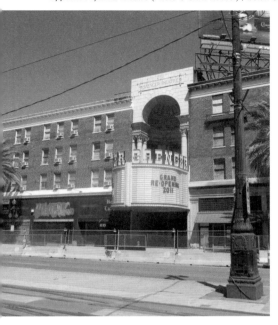

the oldest operating theatre in the Crescent City. However, it does not operate from its original building: that was destroyed by fire in 1927; the cinema was rebuilt on the same site the next year. This classic movie house is now the only independent single-screen movie theatre in the whole state of Louisiana. In the mid-1990s, its operator, René Brunet, purchased the old Prytania Theatre, saving it 'from the wrecking ball' and preserving it as the last remaining traditional neighbourhood movie house in uptown New Orleans.

With an investment of more than a half million dollars in state-of-the-art technology, Brunet established the historic theatre as one of the most advanced movie houses in the area; besides the new digital picture and sound system, the Pyrtania is also equipped to show digital 3D. Additionally, the interior was meticulously

Most of the remaining early movie theatres in New Orleans began as vaudeville houses, such as the opulent Orpheum Theater, where world famous entertainers Harry Houdini, George Burns and Gracie Allen once appeared.

rennovated to ensure it provides the comforts of a modern cinema alongside the charms of an historic one. Thus, in November 2008, at the age of 87, an enterprising owner and devoted film aficionado introduced the first fully digital movie theatre to greater metropolitan New Orleans. As Sharon Keating wrote in 'The Prytania Theatre – A Classic Movie House':

René Brunet can be found every day at his business doing what he loves to do. Showing the latest films and meeting the people who come to see them. You cannot miss him with his signature suit and movie themed tie. He always sports a bright smile an a friendly handshake. He is also a renowned historian who can tell you practically anything about the sixty or more theaters that once populated New Orleans.

Most of the remaining early movie theatres in New Orleans began as vaudeville houses, such as the opulent Orpheum Theater (which opened on University Place in 1921), where world famous entertainers Harry Houdini, George Burns and Gracie Allen once appeared. By the late 1920s, the motion picture theatres were all equipped for sound, and the so-called talkies slowly replaced vaudeville performers completely. Compared to the Prytania Theatre, the flamboyant beaux arts-style Orpheum was one of the more lavish film theatres of the golden movie palace days. Scheduled for demolition in 1979, it was granted a reprieve at the very last minute and eventually underwent major renovation, reopening as the home of the Louisiana Philharmonic Orchestra.

Even so, only a few years ago, in those fateful post-Katrina days, the Orpheum had to be placed on the Louisiana Landmarks Society's list of most endangered historical sites in New Orleans. Severe flooding caused extensive damage to many more historic New Orleans's movie theatres, including the modern Joy Theatre (opened in 1947) on Canal Street; the neighbouring Loew's State Theatre (opened in 1926); and the atmospheric Saenger, which was praised at its opening in 1927 as 'the theatre of the South', and was restored into a performing arts centre in the late 1970s. Whether they will be saved remains to be seen – we must hope though that New Orleans's classic movie theatres meet a happy ending worthy of a classic movie. ✚

GO FURTHER

Recommended reading, useful websites and further viewing

BOOKS

New Orleans Goes to the Movies: Film Sites in the French Quarter and Beyond
Alan T. Leonhard
(Margaret Media Inc, 2008)

Jammin' at the Margins:
Jazz and the American Cinema
Krin Gabbard
(University of Chicago Press, 1996)

FILMS

New Orleans Goes to the Movies:
Film Sites in the French Quarter
and Beyond
Alan T. Leonhard
(Margaret Media Inc, 2008)

The Big Uneasy:
A Film by Harry Shearer
Harry Shearer, dir. (2010)

When the Levees Broke:
A Requiem in Four Acts
Spike Lee, dir.
(40 Acres & A Mule Filmworks, 2006)

If God is Willing and Da Creek Don't Rise,
Spike Lee, dir.
(30 Acres & A Mule Filmworks, 2010)

No More Joy: The Rise and Fall of New
Orleans' Movie Theaters
http://www.nomorejoy.com/

Jazz: A Film by Ken Burns
Ken Burns, dir. (PBS, 2000)

ONLINE

Anya Kamenetz, 'The Short, Shady
History of Hollywood South'
tinyurl.com/dkshg3

Robert Tannenwald, 'State Film Subsidies:
Not Much Bang for Too Many Bucks'
tinyurl.com/85lvytb

The New Orleans Film Commission
www.filmneworleans.org

The New Orleans Film Society
neworleansfilmsociety.org

New Orleans Movies, News and Show Times
www.nola.com/movies

The New Orleans Film Festival and
The New Orleans French Film Festival
neworleansfilmsociety.org

The Original New Orleans Movie Tours
www.nolamovies.com

Louisiana Film Locations: New Orleans
www.louisianafilmlocations.com/NewOrleans

The Louisiana Film Museum
www.louisianafilmmuseum.org

The Pyrtania Theatre
www.theprytania.com

'Classic New Orleans Movies'
www.classicmovies.org/articles/neworleans1.htm

CONTRIBUTORS

Editor and contributing writer biographies

EDITOR

SCOTT JORDAN HARRIS writes for *The Spectator* and edits its arts blog. He is also the editor of several volumes of the *World Film Locations* series and was editor of *The Big Picture* magazine from 2009–11 before being promoted to Senior Editor. A film critic and sportswriter, he has contributed to *BBC Radio*, and been published in several books and by, among others, the *BBC*, *The Guardian*, *Fangoria*, *The Huffington Post*, *Rugby World*, *Film4.com*, *Scope*, *movieScope* and *Film International*. Scott is UK correspondent for Roger Ebert, who lists *@ScottFilmCritic* as one of the top 50 'movie people' to follow on Twitter and featured Scott in his article 'The Golden Age of Movie Critics' as one of the critics he believes is doing most to contribute to that golden age. In 2010, *Running in Heels* named Scott's blog, *A Petrified Fountain* (*http://apetrifiedfountain.blogspot.com*), as one of the world's twelve 'best movie blogs'.

CONTRIBUTORS

SAMIRA AHMED is an award-winning British freelance journalist and broadcaster, with a special interest in cinema and comics. She presents news and arts programmes on BBC Radio and television, including *Night Waves* and *The Proms*; has written for newspapers and magazines, including *The Guardian* and *The Independent*; and has a monthly column in *The Big Issue*. Samira was previously the BBC's Los Angeles correspondent, a reporter on *Newsnight* and a news anchor for *Deutsche Welle TV* in Berlin. From 2000 to 2011, she was a presenter and correspondent for *Channel Four News*. Samira is a trustee of the FILMCLUB charity, which promotes film education in schools.

NICOLA BALKIND is a freelance film journalist and web editor based in Glasgow, Scotland. She holds a BA (Hons) in Film & Media Studies, and MLitt in Film Journalism. She contributes to *The Big Picture* magazine, BBC Radio and regional press, and her thesis on anthropomorphism in animation entitled 'Animation and Automation' was recently published by *Film International*. You can find Nicola online at *http://nicolabalkind.com*.

JOHN BERRA is a lecturer in film studies at Nanjing University, where he teaches a course on the Cinematic City. He is the author of *Declarations of Independence: American Cinema and the Partiality of Independent Production* (2008), the editor of the *Directory of World Cinema: American Independent* (2010/12), the *Directory of World Cinema: Japan* (2010/12), and the co-editor of *World Film Locations: Beijing* (2012). John has contributed essays and entries to *The End: An Electric Sheep Anthology* (2011), *The Companion to Film Noir* (2013), *World Film Locations: New York* (2011) and *World Film Locations: Tokyo* (2011). He is also a regular contributor to *Electric Sheep* and *Film International*

MARCELLINE BLOCK (BA, Harvard; MA, Princeton; Ph.D. candidate, Princeton) has edited several volumes and written articles on literature, visual art and cinema. Her publications include *World Film Locations: Las Vegas* (Intellect, 2012); *World Film Locations: Paris* (Intellect, 2011); and *Situating the Feminist Gaze and Spectatorship in Postwar Cinema* (Cambridge Scholars, 2008; 2010), named Book of the Month for the Arts in January 2012 by its publisher. She contributed chapters to anthologies including *The Many Ways We Talk about Death in Contemporary Society* (2009); *Vendetta: Essays on Honor and Revenge* (2010); and *Cherchez la femme: Women and Values in the Francophone World* (2011). Her articles have appeared in The *Directory of*

CONTRIBUTORS

Editor and contributing writer biographies (continued)

World Cinema: Great Britain (2012) and East Europe (2010); *Excavatio, vol. XXII: Realism and Naturalism in Film Studies* (2007); *The Harvard French Review* (2007) and *Women in French Studies* (2009, 2010). As Lecturer in History at Princeton, she has taught the history and cinema of World War II.

JEZ CONOLLY holds an MA in Film Studies and European Cinema from the University of the West of England, is a regular contributor to *The Big Picture* magazine and website and has co-edited the Dublin and Reykjavik volumes in the *World Film Locations* series with Caroline Whelan. His book *Beached Margin: The role and representation of the seaside resort in British films* was published in 2008. He is currently working on *World Film Locations: Liverpool* and a monograph about John Carpenter's *The Thing*. In his spare time he is the Arts and Social Sciences & Law Faculty Librarian at the University of Bristol.

PETER HOSKIN is a journalist at the London-based magazine *The Spectator*. He graduated with a first-class degree in Politics, Philosophy and Economics from the University of Oxford in 2006, and then spent a brief period in a think-tank, before joining *The Spectator* as online editor in 2008. He writes on politics, literature and film, both for his home publication and other publishers such as *The Times*, *The Telegraph*, *The Daily Beast* and the British Film Institute.

SIMON KINNEAR (@*kinnemaniac* on Twitter) is a freelance film journalist. He is a regular reviewer and feature writer for *Total Film*, and has also written for *SFX*, *Doctor Who Magazine* and *Clothes on Film*. He introduces film screenings at Derby QUAD and writes a

movie blog, *www.kinnemaniac.com*. In addition to this volume of *World Film Locations*, he has contributed to the New York and Glasgow editions.

NEIL MITCHELL is a writer and editor based in Brighton, England. He is the editor of the London and Melbourne editions of the *World Film Locations* series and co-editor of the *Directory of World Cinema: Britain*, also for Intellect Books. He writes for *The Big Picture* and *Electric Sheep* and, as of writing, is working on a monograph on Brian De Palma's *Carrie* for Auteur Publishing.

ELISABETH RAPPE studied History and English Literature at Metropolitan State College of Denver before abandoning academia for film. Her work has been published by *The Spectator*'s arts blog, *Cinematical*, *Film.com*, *MTV*, *Latino Review*, and in *World Film Locations: New York*, and she has offered commentary on geek culture on NPR's *The Takeout* and numerous podcasts. New Orleans is one of her favourite cities to visit (due, in equal parts, to a love of Anne Rice's vampires and Café du Monde's beignets), and she has had the good fortune to visit several New Orleans film sets in the course of her work. One of her fondest New Orleans memories remains having seen Josh Brolin smoke and sleep while buried in his Jonah Hex make-up. She resides on the high plains of Colorado, where she spends her off-time obsessing over Clint Eastwood movies, playing Xbox, and chasing after Elliot the pug and Tuco the parrot.

JONATHAN RAY is the owner of Original New Orleans Movie Tours. Always an avid movie fan, Jonathan began breaking into the film industry in 2009 but then made a change in his plans.

He decided he wanted to drive people around his favourite city, New Orleans, and educate them about its amazing filming history. And so, Original New Orleans Movie Tours was born. The business started in 2009 and, as it is now rated the number one driving tour in the city, Jonathan has turned his dream into a reality.

PAMELA C. SCORZIN, art and media theorist, born in 1965 in Vicenza (Italy), is Professor of Art History and Visual Culture Studies at Dortmund University of Applied Sciences and Arts, Department of Design (Germany). She studied European Art History, English and American Literature, and History in Stuttgart and Heidelberg. She received an MA (1992) and a Ph.D. (1994) in art history at the Ruprecht-Karls-Universit®t in Heidelberg and was Assistant Professor in the Department of Architecture at Darmstadt University of Technology from 1995 to 2000. After completing her ëhabilitationí in history and theory of modern art in Darmstadt in 2001, she stood in for chairs in art history and visual culture in Siegen, Stuttgart and Frankfurt am Main. Since 2005 she is a member of the German section of AICA. Her current areas of research are new media art, installation art, fashion icons, global art design, scenography, and the sonic turn in the contemporary arts. She has published on art-historical as well as cultural-historical topics from the seventeenth to the twenty-first centuries.

FILMOGRAPHY

All films mentioned or featured in this book